Audubon's Birds

of America

BY ROGER TORY PETERSON

& VIRGINIA MARIE PETERSON

ABBEVILLE PRESS PUBLISHERS
NEW YORK LONDON PARIS

The National Audubon Society is among the oldest and largest private conservation organizations in the world. With 550,000 members and 510 local chapters across the country, the Society works in behalf of our national heritage through environmental education and conservation action. It protects wildlife in more than seventy sanctuaries from coast to coast. It also operates outdoor education centers and ecology workshops and publishes the prize-winning *Audubon* magazine, *American Birds* magazine, newsletters, films, and other education materials. For information regarding membership in the Society, write to the National Audubon Society, 950 Third Avenue, New York, N.Y. 10022.

LIBRARY OF CONGRESS CATALOGING-IN-PUBLICATION DATA

Audubon, John James, 1785–1851.
 [Birds of America]
 Audubon's birds of America / [edited] by Roger Tory Peterson &
 Virginia Marie Peterson.—Rev. ed.
 p. cm.
 At head of title: The Audubon Society baby elephant folio.
 ISBN 1-55859-225-3
 1. Birds—North America. 2. Artists—United States—Biography.
3. Ornithologists—United States—Biography. I. Peterson, Roger
Tory, 1908– . II. Peterson, Virginia Marie, 1925–
III. Title. IV. Title: Birds of America.
QL681 .A97 1990
598.2973—dc20 90-31607
 CIP

Edited by Walton Rawls First edition Tiny Folio ™ format, third printing

ISBN-1-55859-225-3

CONTENTS

INTRODUCTION

The Audubon Ethic

Like many another genius, John James Audubon was "the right man in the right place at the right time." He came to America with a fresh eye when it was still possible to document some of our unspoiled wilderness. He was also, during his lifetime, witness to the rapid changes that were taking place. Audubon's real contribution was not the conservation ethic but awareness. That in itself is enough; awareness inevitably leads to concern.

Audubon's frequent references to the palatability of birds and their availability in the market make us realize how far we have come in bird protection, if not in our epicurean tastes. He wrote that "the Barred Owl was very often exposed for sale in the New Orleans market; the Creoles make Gumbo of it, and pronounce the flesh palatable." Not only does he speak with a gourmet's authority about the edibility of owls, loons, cormorants, and crows, but also the gustatory delights of juncos, white-throated sparrows, and robins.

It may seem paradoxical that this prototype of the woodsman-huntsman should have become the father figure of the conservation movement in North America. Like most other pioneer ornithologists, he was literally "in blood up to his elbows." He seemed obsessed with shooting; far more birds fell to his gun than he needed for drawing or research or for food. He once said that it was not a really good day unless he shot a hundred birds. But in his later writings, when recounting old shooting forays, there is a note of regret, as though his conscience were bothering him about the excesses of his trigger-happy days. He deplored the slaughter, especially when perpetrated by others—a double standard, if you will. But only once did he ask forgiveness for his acts. After describing the carnage that took place in the Florida Keys when he and his party landed in a colony of cormorants, "committing frightful havoc among them," he wrote: "You must try to excuse these murders, which in truth might not have been so numerous had I not thought of you [the reader] quite as often while on the Florida Keys, with the burning sun over my head and my body oozing at every pore, as I do now while peaceably scratching my paper with an iron pen, in one of the comfortable and quite cool houses of Old Scotland."

Repeatedly in his writings he reveals this dual nature, or inner conflict. After finding the nest of a pair of least sandpipers he wrote, "I was truly sorry to rob them of their eggs, although impelled to do so by the love of science, which offers a convenient excuse for

even worse acts." Again, when he first met the arctic tern in the Magdalene Islands: "As I admired its easy and graceful motions, I felt agitated with a desire to possess it. Our guns were accordingly charged with mustard-seed shot, and one after another you might have seen the gentle birds come whirling down upon the waters Alas, poor things! How well do I remember the pain it gave me, to be thus obliged to pass and execute sentence upon them. At that very moment I thought of those long past times when individuals of my own species were similarly treated; but I excused myself with plea of necessity, as I recharged my double gun." Another example of Audubon's compulsion to shoot.

In light of his record it would seem inappropriate that one of the foremost conservation organizations in the United States should adopt Audubon's name, but not so. He was ahead of his time. Like so many thoughtful sportsmen since, he eventually developed a conservation conscience. In an era when there were no game laws, no national parks or refuges, when there was no environmental ethic, when vulnerable nature gave way to human pressures and often sheer stupidity, he was a witness who sounded the alarm. He became more and more concerned during his later travels when, with the perspective of his years, he could see the trend. He noticed that prairie chickens, wild turkeys, Carolina parakeets, and many other birds were no longer as numerous as he once knew them. He wrote vividly and passionately about what he saw. He pondered the future, and some of the passages in his writing were prophetic.

Audubon could not have known that because of his artistry and his writing his name would become a household word, synonymous with birds, wildlife, and conservation. The National Audubon Society, formerly known as the National Association of Audubon Societies, was launched in the early years of this century, when no one spoke of "ecology" or "environment." It was primarily a bird organization at first. Over the years the Society has gone through a philosophical metamorphosis. Bird-watching was the precursor of ecological awareness, and "Audubon" has become a symbol of the environmental movement.

John James Audubon received high honors during the two decades prior to his death in 1851, but his greatest fame came in the century that followed. He had sparked a latent nationwide interest in the natural world, especially its birds, and his name became enshrined in hundreds of streets, towns, and parks across the land. Even a mountain peak in the Rockies is named in his honor. In the section of New York City where he lived there is an Audubon Avenue, an Audubon Theatre, and, now translated into digits, an Audubon telephone exchange. There was even a group that called themselves the "Audubon Artists," although they did not draw birds. But the greatest monument to his name is the National Audubon Society, which, unlike the "Audubon gun clubs" before the turn of the century, reflects the other side of John James Audubon, the passionate concern for the survival of wildlife and wild America that he developed as he grew older.

The Audubon Saga

The saga of Audubon has been told many times, with variations. It is not exactly a Horatio Alger tale of rags to riches, because the fledgling Audubon, born out of wedlock, was given a young gentleman's tutoring and was all but spoiled by an indulgent stepmother.

Jean Jacques Fougère Audubon was born in 1785 on the island of Santo Domingo, now Haiti, in the West Indies. He was the son of an enterprising French sea captain who, after reverses in Les Cayes, where he owned property, returned to France with the boy. His mother was a young lady, Mademoiselle Rabin, originally from Nantes, who died before the captain returned to his home and legal wife in France. How he explained his transgressions to Madame Audubon is not known, but she took the four-year-old boy to her heart as her own as she did his sister, also born out of wedlock.

Perhaps to enable his son to escape conscription in Napoleon's army, or perhaps to help him avoid the stigma of illegitimacy, Captain Audubon sent Jean Jacques at the age of eighteen to Mill Grove near Philadelphia where he owned property. The birds of America fascinated young Audubon, and drawing them became an obsession from which he never freed himself.

Audubon performed an experiment at Mill Grove that marked a "first" in the history of ornithology. He was fascinated by the phoebes that lived along the creek near his home. By placing silver threads about the legs of a brood of young phoebes to see whether they would return the following year, he became the first bird bander (or "ringer," to use the British term).

At Mill Grove Audubon married Lucy Bakewell, the daughter of a neighbor. Shortly thereafter the young couple moved westward to Louisville, Kentucky, where Jean Jacques's father had set him up in business. But business was not in his blood, or so it seemed. It must be admitted that times were uncertain and investment risky on the frontier in those days. Moving farther west to the Mississippi and then down to New Orleans, Audubon met successive reverses until he was almost reduced to penury. Some called him impractical.

In reviewing this difficult period Audubon wrote, "Birds were then as now I drew, I looked on nature only; my days were happy beyond human conception." He had conceived a grandiose plan of painting all the birds of North America—at least all then known—and at no time did he lose sight of this goal. He may have harbored the idea of eventual publication from the start, but it seems that the unheralded visit by pioneer ornithologist Alexander Wilson stirred his competitive spirit to action.

Audubon was often away from his family for months, exploring the wilderness, painting, and pursuing his dream. His devoted Lucy, who had borne him two sons,

Victor and John, kept home and hearth together by teaching. He himself eked out a living as an itinerant portrait painter and as a dancing and fencing instructor.

As his portfolio bulged he began to look for a patron or a publisher, but he could find none in New York or Philadelphia. No one would risk the capital in those difficult days. Audubon decided that there might be a better chance of success in England, so with Lucy's savings as a teacher and some money he had managed to acquire by painting portraits of well-to-do people, he set sail in 1826.

Abroad he was acclaimed immediately. Although he had been a nobody on his home turf, the rough, colorful man from the American frontier was a sensation abroad. He fascinated the genteel patrons of the art salons in London, Edinburgh, and Paris. Madison Avenue would have admired his public relations techniques. Long ahead of his time in the art of showmanship, he played his part well. To fit the image of the American woodsman, he wore buckskin and allowed his hair to grow long over his shoulders. The former bankrupt businessman became a supersalesman, traveling from city to city to secure subscriptions. Meanwhile, as a sort of production manager, he monitored with infinite care the work of the engravers and a corps of colorists. He was not only artist, author, and scientist but also publisher, business manager, treasurer, and bill collector.

How could he have been "irresponsible" or "impractical" if he could do all this?

William Lizars of Edinburgh agreed to engrave and publish his work, but when only ten plates had been finished the colorists went on strike and Audubon was forced to find another engraver. This was Robert Havell, Jr., of London. Audubon was fortunate to be in the hands of such a skilled craftsman and artist. Havell's accomplishment in etching the copper plates was as much a tour de force as the original paintings. It is instructive to compare the watercolors that hang in the galleries of the New-York Historical Society to the Havell prints with which most of us are familiar.

In his 435 colorplates, Audubon depicted the birds exactly the size they were in life. Even the oversize format, 29½ by 39½ inches (known as "double-elephant folio"), the largest ever attempted up to then in the history of book publishing, was insufficient to accommodate the largest birds comfortably. Tall birds, such as the flamingo and the great blue heron, were fitted in by drooping their long necks toward their feet. On the other hand, tiny birds, such as kinglets and hummingbirds, are all but lost on the page.

Among the last few plates in the Elephant Folio and the 65 additional ones in the smaller octavo edition, Audubon included a number of birds from the western part of the country. These were his least successful efforts, probably because he had not seen these species in life.

Audubon as an Artist

Audubon implied that as a youth he had studied under the French master Jacques Louis David, and in doing so laid the foundation of his ability to draw. However, recent research has disputed this. Perhaps it was a good thing that his art was truly his own; like many another innovative genius he was not a clone of his professor. Nor were his paintings like the dull, documentary drawings of Alexander Wilson and his other contemporaries.

The thing that separated Audubon from his predecessors was that he was the first to give his birds the simulation of life. The others portrayed them stiffly and archaically as though they were on museum pedestals. To invest his birds with vitality and movement, Audubon worked from freshly killed specimens, wiring them into lifelike positions. In his youth he had tried hundreds of outline sketches but found it difficult to finish them. He fashioned a wooden model, "a tolerable-looking Dodo I gave it a kick, broke it to atoms, walked off, and thought again." It was then that he conceived the procedure he was to follow for many years. He wrote: "One morning I leapt out of bed . . . went to the river, took a bath and returning to town inquired for wire of different sizes, bought some and was soon again at Mill Grove. I shot the first Kingfisher I met, pierced the body with wire, fixed it to the board, another wire held the head, smaller ones fixed the feet There stood before me the real Kingfisher. I outlined the bird, colored it. This was my first drawing actually from nature."

It has been remarked that a Fuertes bird in repose has more the essence of the living bird than an Audubon bird vividly animated. This is understandable when one keeps in mind that Audubon wired up his specimens, and they sometimes looked it. In most cases this method worked fairly well, but the wild turkey cock, wired with its head looking over its back so as to fit the sheet, is almost a caricature. So are Audubon's barred owl with the grinning squirrel and his two red-tailed hawks quarreling in mid-air for possession of a rabbit. His golden eagle frozen in flight with a hare, his two barn owls at night, and his squabbling caracaras are all too contrived. His two blue-winged teals look as though they were thrown through the air like footballs. Inasmuch as Audubon did not know some of the pelagic birds—the fulmar, greater shearwater, and tropic-bird—on their nesting ground, he showed them standing on their toes rather than resting on their bellies with their tarsi flat on the ground.

We can if we choose, be critical of these errors, but the wildlife artist of today is able to step on the shoulders of those who have gone before. In fairness, Audubon made the great leap forward at a time when most birds were drawn as though "stuffed" and fastened to wooden perches in museum cases. He took birds out of the glass case for all time and gave them a semblance of life. His paintings have a dramatic impact seldom equaled by those of his successors.

Louis Agassiz Fuertes, in a remarkable letter to his young protégé George Miksch Sutton, extolled Audubon's strengths and defended his shortcomings, unaware that his "training under David" was apparently a myth:

> Say what you will of Audubon, he was the first and only man whose bird drawings showed the faintest hint of anatomical study, or that the fresh bird was in hand when the work was done, and is so immeasurably ahead of anything, up to his time or since, until the modern idea of drawing endlessly from life began to bear fruit, that his strength deserves all praise and honor, and its many weaknesses condonement, as they were the fruit of his training; stilted, tight, and unimaginative old [Jacques Louis] David sticks out in the stiff landscape, the hard outline, and the dull, lifeless shading, while the overpowering virility of Audubon is shown in the snappy, instantaneous attitudes, and dashing motion of his subjects. While there's much to criticize there is also much to learn, and much to admire, in studying the monumental classic that he left behind him. He made many errors, but he also left a living record that has been of inestimable value and stimulus to students, and made an everlasting mark in American ornithology. It is indeed hard to imagine what the science would be like in this country—and what the state of our bird world—had he not lived and wrought, and become a demigod to the ardent youth of the land. (From *Bird Study, an Autobiography,* by George Miksch Sutton, Austin: University of Texas Press, 1980.)

Sutton, who himself later became a distinguished bird artist, wrote: "It was Audubon's instinctive urge to dramatize which led him to represent so many of his birds in violent action. As several admirers of the great artist have pointed out, he was so surfeited with the conventional and lifeless poses used by the bird artists before him that he swung away from the traditional in a sort of furious huff This was Audubon, lover of beauty, lover of the dramatic, avowed opponent of the prosy." If his art had been less startling and dramatic, it probably would not have survived and we would have heard little about Audubon, for relatively few people read his extensive writings.

In the beginning, Audubon vowed he would paint only from fresh specimens of birds he had collected after observing them in life. Halfway through his project, this resolve broke down. While he was involved in reproducing his paintings in London, many new species were being discovered in the American West. Since he had no immediate hope of reaching the Rockies or the Pacific himself, he was forced to draw them from specimens furnished by Dr. Thomas Nuttall, a New England botanist, and Dr. John Kirk Townsend, an experienced ornithologist, who set out together in 1834 on an exploratory journey to the mouth of the Columbia River. Captain Ross of the Royal Navy furnished additional seabirds that had been taken during his explorations in the Arctic. Other specimens were borrowed from the British Museum. Few of Audubon's later drawings were as inspired as his earlier efforts, because he had never seen these species in life. Many single drawings showed three, four, or five species.

Apprentices

Much has been said of the fine sense of pattern and composition in some of Audubon's plates. However, it should be pointed out that, like many another artist of an earlier day, he had apprentices. Many of the backgrounds, leaves, flowers, and other botanical accessories were painted by others, but the birds in almost every instance were the work of the master himself. Some compositions remind us of Chinese prints, but we are quite sure Audubon's work was in no way imitative.

The elaborate composition of black-billed cuckoos (plate 233) was probably a cooperative effort. Although Audubon did not give him credit, it is quite certain that Joseph Mason painted the magnolia blossoms and leaves. Audubon wrote to Lucy, "He now draws flowers better than any man probably in America."

Joseph Mason, who as a remarkable boy of thirteen had been one of Audubon's pupils in Cincinnati when he was giving art lessons to raise funds, showed such promise as a botanical artist that Audubon took him on his 1820 trip down the Mississippi. Mason was his assistant for about two years, and most of the leaves and flowers in those plates painted in Louisiana during 1821 and 1822 are his work. He was incredibly skillful for a youngster of that age. At least 57 backgrounds are credited to this young genius. He seems to have disappeared into limbo after leaving Audubon's employ, but he is immortalized in Audubon's bird prints.

During the next several years Audubon may have painted his own backgrounds, but in 1829 he met George Lehman, who was to assist him for the next four years, accompanying him on his trips to the shore and to Florida. Although Lehman was an experienced landscape painter, his leaves and other accessories are a bit more labored and cluttered than those of Mason, who had an innate sense of abstraction and pattern. Lehman's landscapes give a different look to many of the paintings that were made during that productive period; they were more environmental, but less decorative. Lehman is known to have painted the backgrounds for about forty plates, but he probably did more. He even painted an occasional bird; the lesser yellowlegs in plate 163 is credited to him.

Time was important once the great work was fully under way. Flowers and leaves took as long to paint as the birds, so Audubon was pleased to enlist a third helper, whom he met in Charleston, a maiden lady by the name of Maria Martin, who later became Reverend John Bachman's second wife. She had a well-tended garden, painted flowers and butterflies quite well, and is credited with drawing the flowers and leaves in about twenty of the paintings. They are not the equal of Joseph Mason's work; her twigs and stems lack his structural strength. The butterflies and moths that appear in six of the plates are presumably hers.

Audubon's two sons were also drawn into the project. His younger son, John Woodhouse Audubon, who became an accomplished artist, helped with some of the work while in London and actually drew a few of the birds, notably the American bitterns in plate 40. The elder son, Victor Gifford Audubon, painted some of the backgrounds in the later western subjects, but they are more stilted than those of Lehman. It is believed that even Lucy Audubon may have painted at least one bird, the swamp sparrow (plate 426). Add to these efforts the skill and expedient innovation of Robert Havell, Jr., the engraver, who improvised branches and twigs where needed, or even full backgrounds where none existed, and we have, in effect, paintings by committee.

Twelve years after Audubon's death in 1851, his widow Lucy sold the original paintings to the New-York Historical Society, where they can be seen today. Reproductions of Audubon's work invariably were made from the Havell prints until 1966, when the American Heritage Publishing Company of New York and the Houghton Mifflin Company of Boston went directly to the original watercolors. It is instructive to compare the originals with the prints, because Havell was in a sense no less a genius than Audubon and left his own artistic stamp on the plates, sometimes even improving them. Some are literally scissors-and-paste jobs. A pastel made in 1820 might be copied in watercolor ten or twelve years later or simply cut out and pasted onto another drawing. Audubon did not hesitate to mix mediums. Pencil, ink, pastel, watercolor, and even oil were combined in some compositions.

America was reawakened to the splendor of Audubon's work in 1937, when the Macmillan Company of New York reproduced, in smaller size, 435 prints from the Elephant Folio and an additional 65 prints from the octavo edition. Although the reproductions left much to be desired, they were a breakthrough. Audubon's prints have been reproduced a number of times since in various forms, and they reached their greatest audience when they graced the calendars of the Northwestern Mutual Life Insurance Company of Milwaukee. Over a period of twenty years more than ten million well-reproduced and framable Audubon prints were distributed in these calendars.

The Double Elephant Folio

Audubon's reputation skyrocketed upon publication of his great work. Baron Cuvier, the French naturalist, rated it the "most magnificent monument which has ever been raised to ornithology." But every genius has his or her critics. One subscriber discontinued her subscription after she received the first lot of prints, numbers 1 to 9. She pronounced them so very bad that she could not think of giving "house room" to any more such "trash."

Not counting his own living costs and those of his family, Audubon spent $115,640 to complete his project. Approximately 200 sets of the Double Elephant Folio were bound and distributed. They were priced at $1,000 each. It was thought that more than half these sets had been broken up by 1970 and sold by dealers as individual prints. However, through the extraordinary investigation of Waldeman H. Fries, we find this was far from true. When he documented the sets in his scholarly work *The Double Elephant Folio: The Story of Audubon's Birds of America* (Chicago: American Library Association, 1973), about 134 complete sets survived. Of these, 94 were in the United States, 17 in England, and the remainder in twelve other countries. It attests to the fortitude of Fries (and his wife) that he was able to examine all but six of these sets. In addition, 14 incomplete sets survived, 28 sets were broken up, 11 were destroyed by fire or war, and 14 had disappeared. It was rumored that one unanticipated spinoff of the Fries book was that thieves, finding the locations of existing sets pinpointed, made off with three of them. All three were eventually recovered.

Nearly a century elapsed before the original investment of $1,000 per set really began to pay off in the collector's market, in direct proportion to the vastly increased interest in birds that had begun to accelerate with the publication of modern field guides. In the 1920s, a collector or speculator could have acquired a set of Audubon at auction for about $2,500. By the mid- or late thirties it would have been closer to $12,000 or $14,000; by the mid-forties, $18,000; in 1960, $60,000 was paid for a set; and in 1969, $216,000. In 1977 a set was sold at auction for $400,000, and the price continued to climb. On June 23, 1989, at an auction at Sotheby's, the total realized from a set that had been broken up was $3,960,000!

Individual prints that could have been purchased at Goodspeeds in Boston for $7.50 to $25.00 in 1905 went for $500 to $4,000 or more in the late 1970s. The wild turkey—"The Great American Cock"—rose from $200 in 1905 to $20,000 in 1980 for one in mint condition. At an auction at Sotheby's in 1989 a print of the mallard that fetched $45,100 was bettered by four prints: the trumpeter swan ($49,500), the white pelican ($58,300), the great blue heron ($66,000), and the flamingo ($66,550), much more than presale estimates. Whether this says more about Audubon or about the inflated art market is debatable.

It is plain that not all of Audubon's prints are of equal appeal or merit, nor do they command equal prices. The very lowest price for any print would be not much less than $700. Waterfowl bring higher prices than songbirds. Whereas a duck or a heron might cost thousands, a wren might be had for less than $700. Similarly, in Audubon's *Viviparous Quadrupeds of North America*, published later, a deer would bring more than $1,000, but a mole or a shrew might go for as little as $300.

The excellent little *Handbook of Audubon Prints* by Taylor Clark and Lois Elmer Bannon (Gretna, Louisiana: Pelican Publishing Company, 1980) gives in concise form not only the prices (at that time) of Havell and Bien prints in good condition but also the locality where each bird was painted, the date, and, when known, the artist who worked on the background.

The Ornithological Biography

Once the engraving and coloring of the first hundred of his bird portraits was in progress, Audubon began work on a text to accompany them. It had been British law since 1709 that any published work with letterpress accompanying the illustrations was a proper book. Therefore, if Audubon were to combine text and illustrations within the same covers, he would have to deposit a copy of the work in each of nine libraries in the United Kingdom. To get around this ruling, his *Ornithological Biography, or an Account of the Habits of the Birds of the United States* was printed separately in five volumes. The texts were in the order in which the birds appeared in the colorplates.

Fully aware of his own shortcomings as a man of letters, Audubon had the help of his wife in spelling, punctuation, and grammatical structure. He then asked William Swainson if he would take on the role of general editor. Swainson requested a fee of 250 pounds sterling per volume. This was plainly more than Audubon could afford, so he finally made an arrangement with William MacGillivray, of the University of Edinburgh, who agreed to do the job for 50 to 60 pounds per volume. MacGillivray not only edited Audubon's text but contributed lengthy descriptions of the anatomy of many species. These were usually accompanied by his own line drawings. Audubon himself became a fair anatomist through this working association with a very devoted friend. MacGillivray suggested the inclusion of a series of essays, "Delineations of American Scenery and Character." The argument for interspersing an essay here and there was to keep the reader from being bored by a steady diet of birds.

Although Audubon's immortality rests largely on his work as an artist, he was no less important as an ornithologist. The wealth of observation detailed in the 3,500 pages of his *Ornithological Biography* remains the guide for comparing the status of birds then and now. Also important as a historical record are his "delineations" of places, people, and customs.

Judging by his descriptions of bird voices, Audubon had a very poor ear, particularly when describing some of the high-pitched warblers, which he flatly stated had no song. Obviously, he had been banging away with his fowling piece so much since his youth that his eardrums were as insensitive as those of some modern rock musicians.

After three intensely active years in England, Scotland, and France, Audubon returned to America in 1829 to paint additional birds, to try for more subscriptions, and to travel extensively and fill in the gaps. Eventually his journeys took him from the Gulf Coast and the Florida Keys to Labrador and westward to the foothills of the Rockies. It took twelve years to complete the publication of the plates and their accompanying texts in the *Ornithological Biography*.

The Octavo Edition

Even before the Elephant Folio and the *Ornithological Biography* were completed, Audubon began to plan an octavo version that he hoped would reach an audience far larger than the few libraries and very rich people fortunate enough to own the big work. The octavo *Birds of America* appeared in seven volumes from 1840 to 1844. It met with immediate success, and the first edition of 1200 copies was quickly sold. This was followed by seven more editions (not counting recent reprints).

Because several years had elapsed since the *Ornithological Biography* was written, many new facts about birds were known, and accordingly changes were made in nomenclature and in the text. Stability in bird names had not yet been achieved, so Audubon included a synonymy that brought things up to date. The plates, this time bound with the text, were miniaturized by black-and-white lithography and then hand-tinted by a corps of as many as 70 colorists. In the octavo, related birds were grouped together, not presented in the haphazard order in which they appeared in the Elephant Folio. Sixty-five new plates were added, bringing the total to 500. A few represented newly discovered birds from the West. Other plates were individual repeats of species that had been lumped in some of the composite plates. The "Delineations of American Scenery and Character" were omitted on the advice of his friend the Reverend Bachman, who said it was all "humbug."

The Quadrupeds

As he advanced in years, Audubon had changed from the "impractical dreamer" to a "workaholic" in every sense of the word. A driven man, he had scarcely brought to completion his herculean task on the Elephant Folio and gotten started on his octavo edition of *Birds of America* before he laid plans for his two-volume *Viviparous Quadrupeds of North America*, in collaboration with his two sons and the Reverend Bachman of Charleston, who had become a devoted friend. Toward this end Audubon tried to get government support in 1842 for a research expedition to the Rockies, but without success. The following year, however, the American Fur Company offered him transportation up the Missouri River as far as the Yellowstone River. This enabled him to draw many of the western mammals in the field. But about three years later, before the plates were half completed, his eyes and his mind began to fail, possibly from a stroke, and he was forced to lay down his brushes forever. On January 27, 1851, Jean Jacques Fougère Audubon died, "as gently as a child composing himself for his beautiful sleep." He had not reached his sixty-seventh year. Meanwhile, the remaining mammals were painted, mostly in oil, by his son John, while his son Victor filled in most of the backgrounds. Reverend Bachman finished the manuscript and brought the *Quadrupeds* to completion in 1852. It was truly a cooperative family effort, as Bachman's two daughters had married Audubon's sons.

I

DIVERS OF LAKES AND BAYS,
WANDERERS OF SEAS AND COASTS

Loons, Grebes, Albatrosses, Fulmars, Shearwaters,
Storm Petrels, Tropicbirds, Pelicans,
Boobies, Gannets, Cormorants, Darters, Frigatebirds,
Herons, Bitterns, Storks, Ibises, Spoonbills, and Flamingos

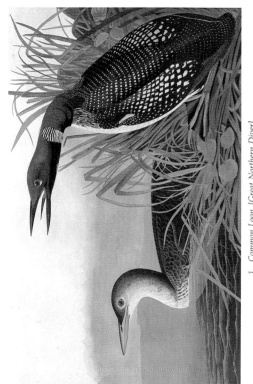

1 *Common Loon [Great Northern Diver]*
Gaviiformes Gaviidae *Gavia immer*

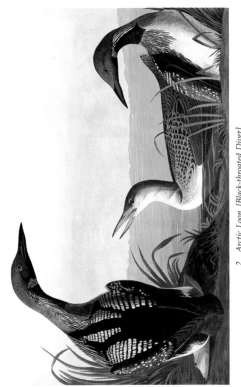

2 *Arctic Loon* [*Black-throated Diver*]
Gaviiformes Gaviidae *Gavia arctica*

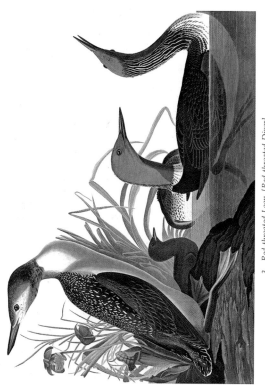

3 Red-throated Loon [Red-throated Diver]
Gaviiformes Gaviidae *Gavia stellata*

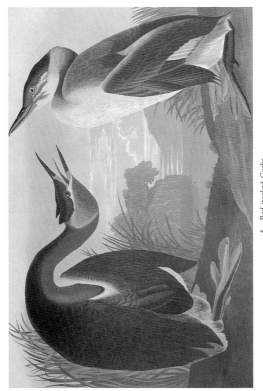

4 *Red-necked Grebe*
Podicipediformes Podicipedidae *Podiceps grisegena*

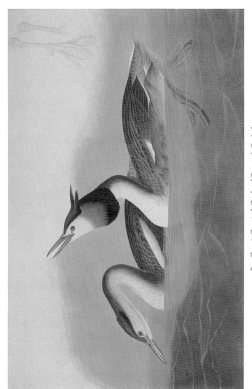

5 *Great Crested Grebe* [Crested Grebe]
Podicipediformes Podicipedidae *Podiceps cristatus*

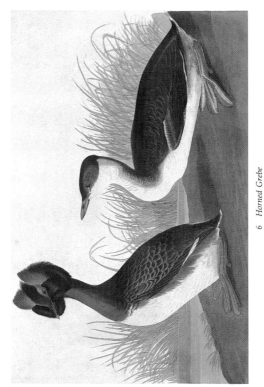

6 *Horned Grebe*
Podicipediformes Podicipedidae *Podiceps auritus*

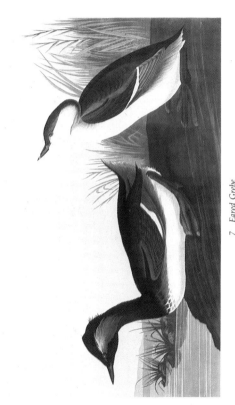

7 *Eared Grebe*
Podicipediformes Podicipedidae *Podiceps nigricollis*

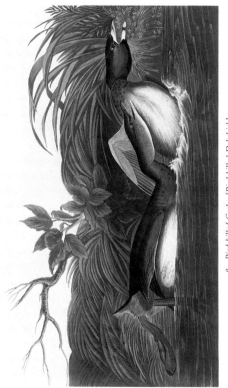

8 *Pied-billed Grebe [Pied-billed Dobchick]*
Podicipediformes Podicipedidae *Podilymbus podiceps*

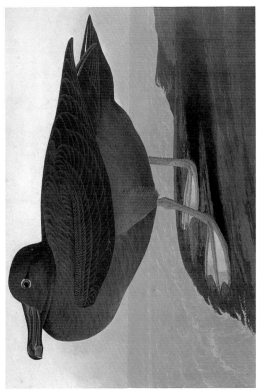

9 *Sooty Albatross* [*Dusky Albatross*]
Procellariiformes Diomedeidae *Phoebetria palpebrata*

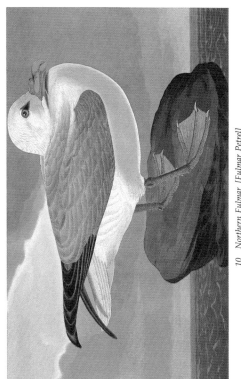

10 *Northern Fulmar [Fulmar Petrel]*
Procellariiformes Procellariidae *Fulmarus glacialis*

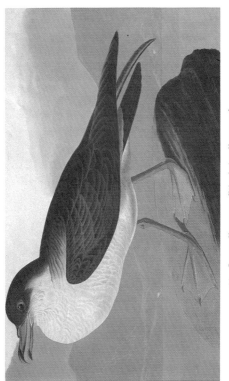

11 *Greater Shearwater [Wandering Shearwater]*
Procellariiformes Procellariidae *Puffinus gravis*

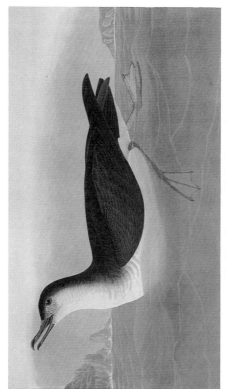

12　*Manx Shearwater [Manks Shearwater]*
Procellariiformes Procellariidae *Puffinus puffinus*

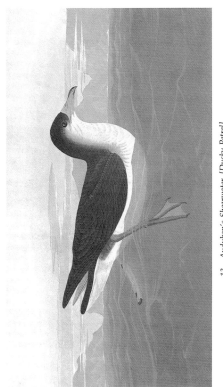

13 *Audubon's Shearwater [Dusky Petrel]*
Procellariiformes Procellariidae *Puffinus lherminieri*

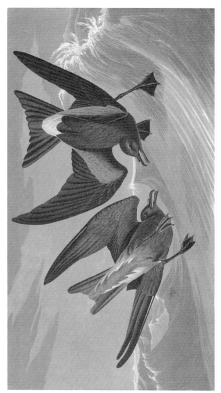

14 *Leach's Storm-Petrel* [Forked-tailed Petrel]
Procellariiformes Hydrobatidae *Oceanodroma leucorhoa*

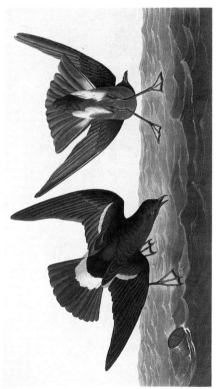

15 *Wilson's Storm-Petrel* [*Wilson's Petrel*]
Procellariiformes Hydrobatidae *Oceanites oceanicus*

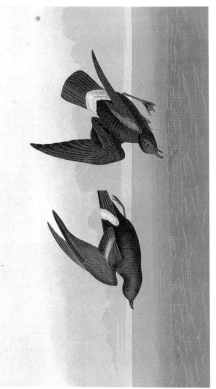

16 *British Storm-Petrel* [Least Petrel]
Procellariiformes Hydrobatidae *Hydrobates pelagicus*

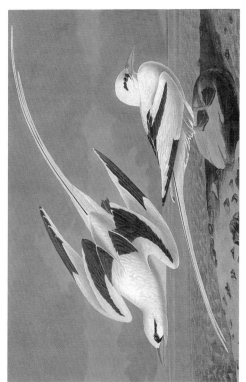

17 *White-tailed Tropicbird* [Tropic Bird]
Pelecaniformes Phaethontidae *Phaethon lepturus*

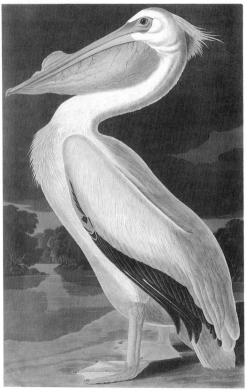

18　American White Pelican

Pelecaniformes Pelecanidae *Pelecanus erythrorhynchos*

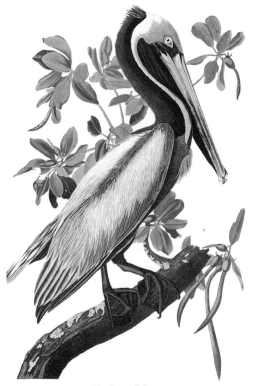

19 Brown Pelican
Pelecaniformes Pelecanidae *Pelecanus occidentalis*

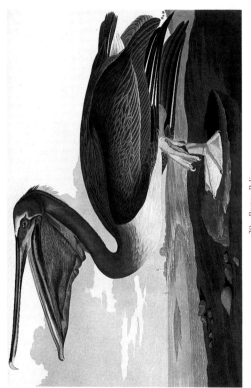

20 *Brown Pelican*
Pelecaniformes Pelecanidae *Pelecanus occidentalis*

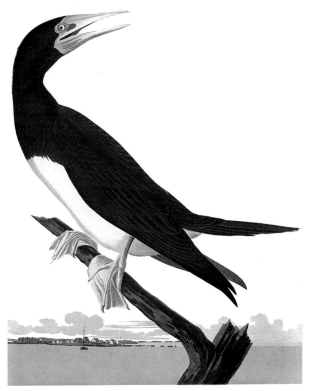

21 *Brown Booby* [Booby Gannet]
Pelecaniformes Sulidae *Sula leucogaster*

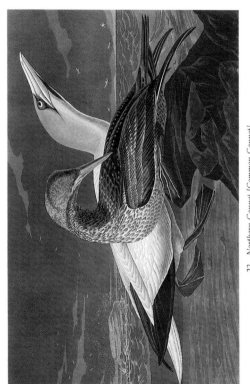

22 *Northern Gannet [Common Gannet]*
Pelecaniformes Sulidae *Sula bassanus*

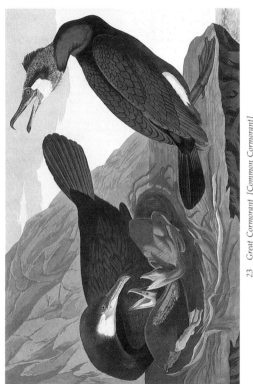

23 *Great Cormorant* [*Common Cormorant*]
Pelecaniformes Phalacrocoracidae *Phalacrocorax carbo*

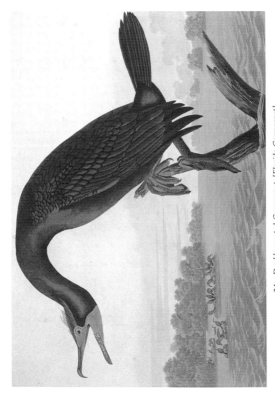

24 *Double-crested Cormorant* [Florida Cormorant]
Pelecaniformes Phalacrocoracidae *Phalacrocorax auritus*

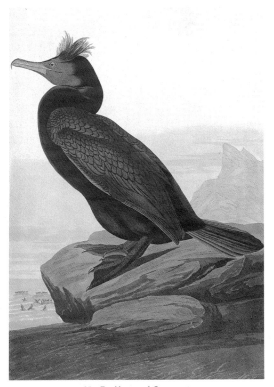

25 *Double-crested Cormorant*
Pelecaniformes Phalacrocoracidae *Phalacrocorax auritus*

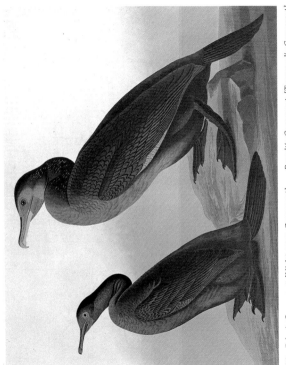

26 *Pelagic Cormorant [Violet-green Cormorant]*
Pelecaniformes Phalacrocoracidae *Phalacrocorax pelagicus*

Brandt's Cormorant [Townsend's Cormorant]
Pelecaniformes Phalacrocoracidae *Phalacrocorax penicillatus*

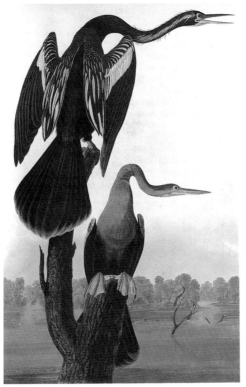

27 *American Anhinga [Black-bellied Darter]*
Pelecaniformes Anhingidae *Anhinga anhinga*

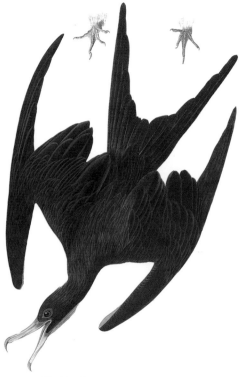

28 *Magnificent Frigatebird* [Frigate Pelican]
Pelecaniformes Fregatidae *Fregata magnificens*

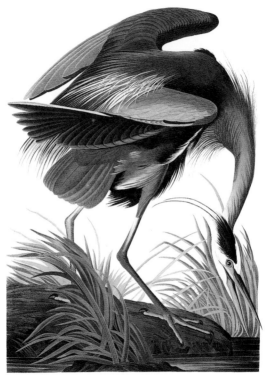

29 *Great Blue Heron*
Ciconiiformes Ardeidae *Ardea herodias*

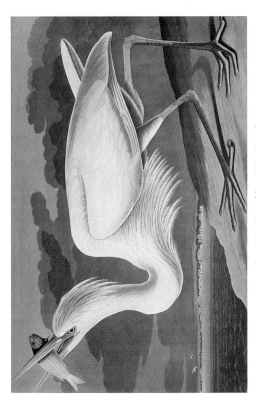

30 *Great Blue Heron* [*Great White Heron*]
Ciconiiformes Ardeidae *Ardea herodias*

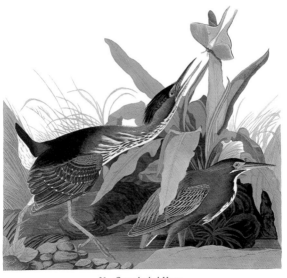

31 Green-backed Heron
Ciconiiformes Ardeidae *Butorides striatus*

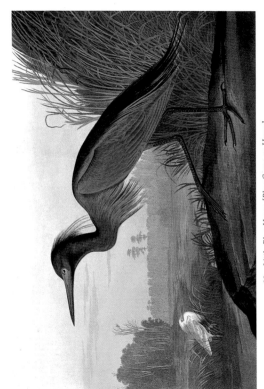

32 *Little Blue Heron [Blue Crane or Heron]*
Ciconiiformes Ardeidae *Egretta caerulea*

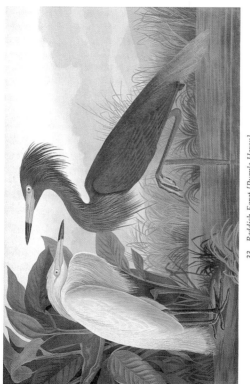

33 *Reddish Egret [Purple Heron]*
Ciconiiformes Ardeidae *Egretta rufescens*

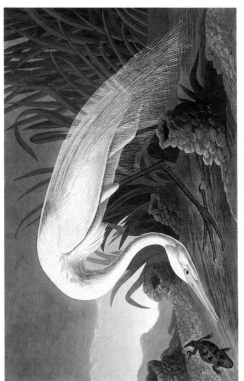

34 *Great Egret* [White Heron]
Ciconiiformes Ardeidae *Casmerodius albus*

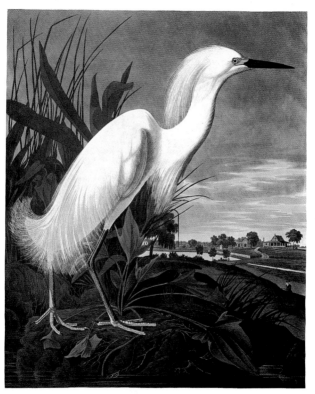

35 *Snowy Egret [Snowy Heron]*
Ciconiiformes Ardeidae *Egretta thula*

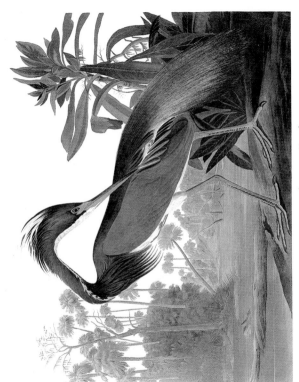

36 *Tricolored Heron [Louisiana Heron]*
Ciconiiformes Ardeidae *Egretta tricolor*

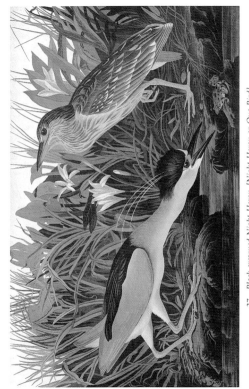

37 *Black-crowned Night Heron* [Night Heron or Qua Bird]
Ciconiiformes Ardeidae *Nycticorax nycticorax*

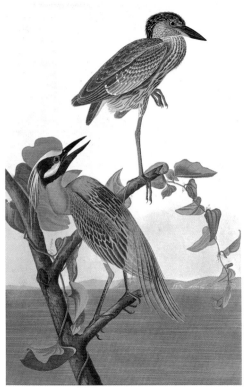

38 *Yellow-crowned Night-Heron [Yellow-crowned Heron]*
Ciconiiformes Ardeidae *Nycticorax violaceus*

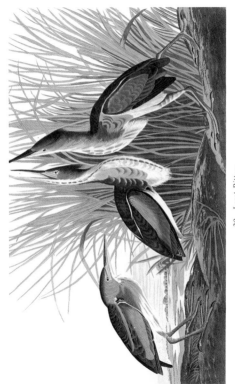

39 *Least Bittern*
Ciconiiformes Ardeidae *Ixobrychus exilis*

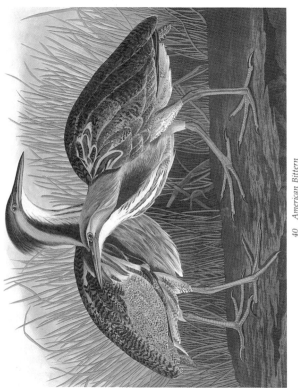

40 *American Bittern*
Ciconiiformes Ardeidae *Botaurus lentiginosus*

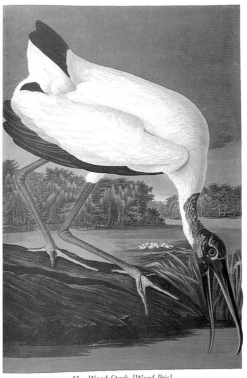

41 Wood Stork [Wood Ibis]
Ciconiiformes Ciconiidae *Mycteria americana*

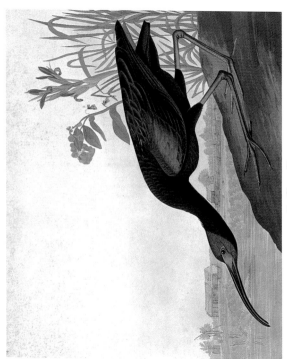

42 *Glossy Ibis*
Ciconiiformes Threskiornithidae *Plegadis falcinellus*

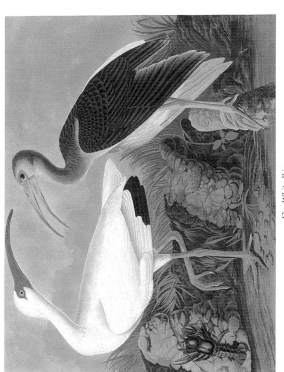

43 *White Ibis*

Ciconiiformes Threskiornithidae *Eudocimus albus*

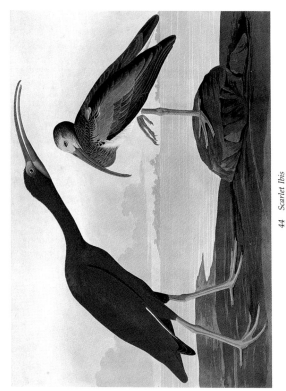

44 *Scarlet Ibis*
Ciconiiformes Threskiornithidae *Eudocimus ruber*

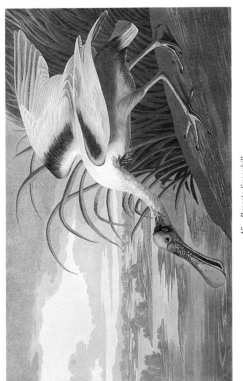

45 *Roseate Spoonbill*
Ciconiiformes Threskiornithidae *Ajaia ajaja*

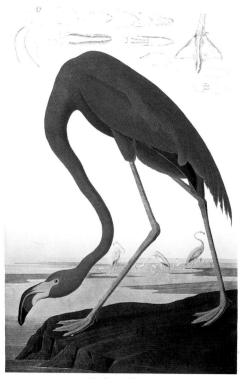

46 *Greater Flamingo*
Phoenicopteriformes Phoenicopteridae *Phoenicopterus ruber*

II

WATERFOWL

Swans, Geese, and Ducks

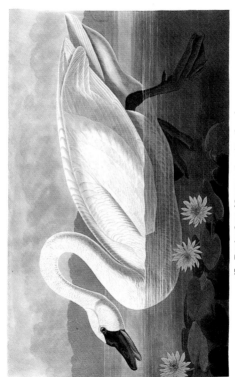

47 *Tundra Swan [Common American Swan]*
Anseriformes Anatidae *Cygnus columbianus*

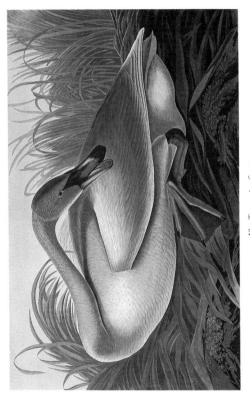

48 *Trumpeter Swan*
Anseriformes Anatidae *Cygnus buccinator*

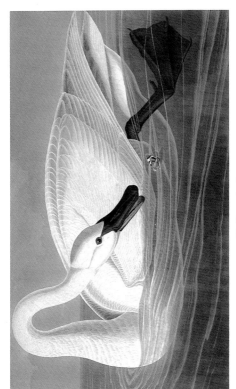

49 Trumpeter Swan
Anseriformes Anatidae *Cygnus buccinator*

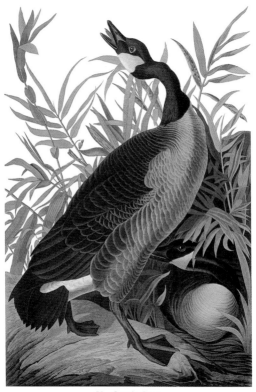

50 Canada Goose

Anseriformes Anatidae *Branta canadensis*

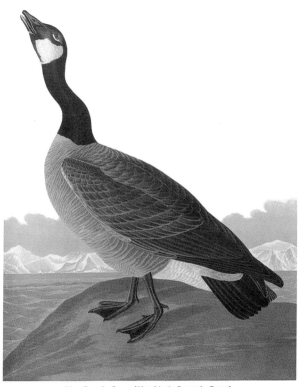

51 *Canada Goose [Hutchins's Barnacle Goose]*
Anseriformes Anatidae *Branta canadensis*

52 *Brant* [*Brent Goose*]
Anseriformes Anatidae *Branta bernicla*

53 *Barnacle Goose*

Anseriformes Anatidae *Branta leucopsis*

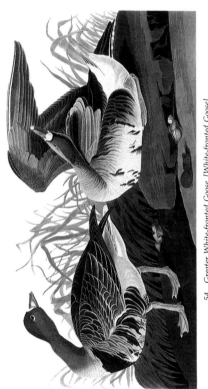

54 *Greater White-fronted Goose* [White-fronted Goose]
Anseriformes Anatidae *Anser albifrons*

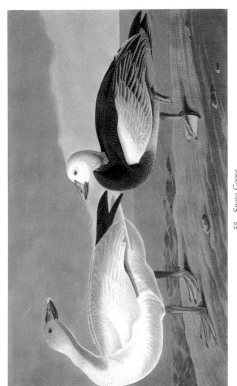

55 *Snow Goose*

Anseriformes Anatidae *Chen caerulescens*

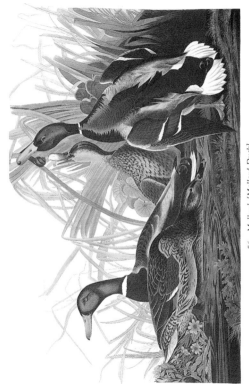

56 *Mallard* [Mallard Duck]
Anseriformes Anatidae *Anas platyrhynchos*

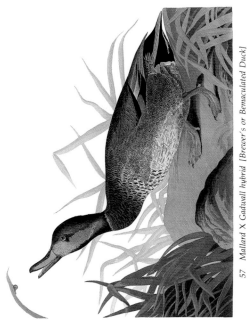

57 *Mallard X Gadwall hybrid [Brewer's or Bemaculated Duck]*
Anseriformes Anatidae *Anas platyrhynchos X strepera*

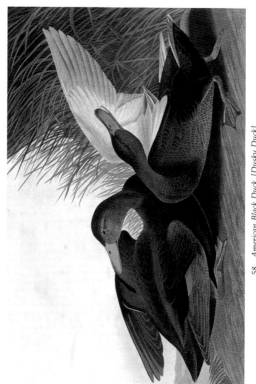

58 *American Black Duck [Dusky Duck]*
Anseriformes Anatidae *Anas rubripes*

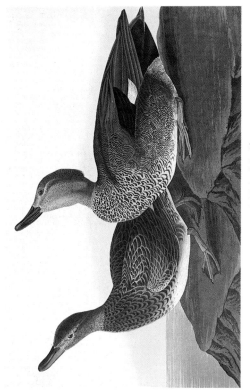

59 *Gadwall [Gadwall Duck]*
Anseriformes Anatidae *Anas strepera*

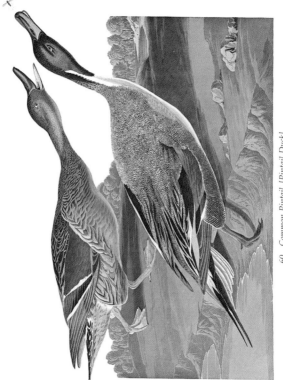

60 *Common Pintail* [*Pintail Duck*]
Anseriformes Anatidae *Anas acuta*

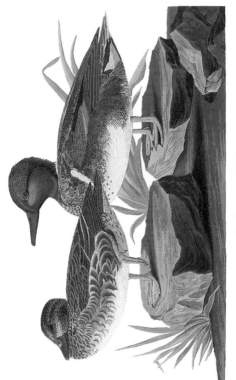

61 *Green-winged Teal*
Anseriformes Anatidae *Anas crecca*

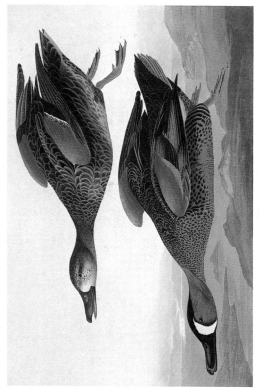

62 *Blue-winged Teal*
Anseriformes Anatidae *Anas discors*

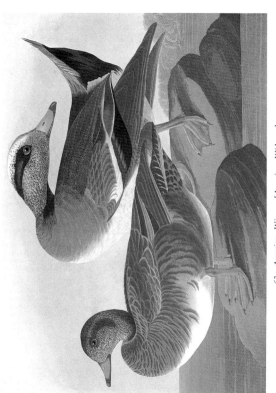

63 *American Wigeon* [American Widgeon]
Anseriformes Anatidae *Anas americana*

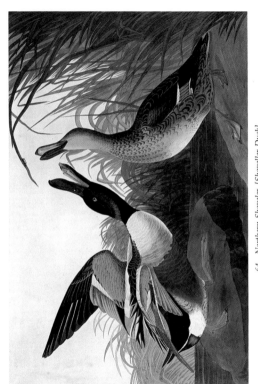

64 *Northern Shoveler [Shoveller Duck]*
Anseriformes Anatidae *Anas clypeata*

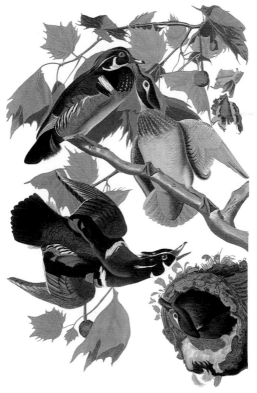

65　Wood Duck [Summer or Wood Duck]
Anseriformes Anatidae *Aix sponsa*

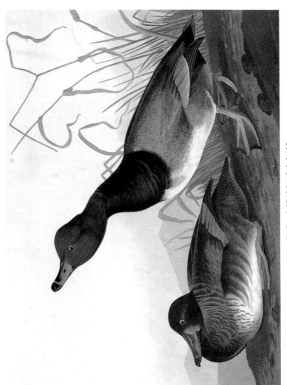

66 *Redhead [Red-headed duck]*
Anseriformes Anatidae *Aythya americana*

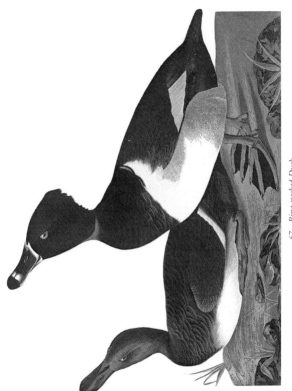

67 *Ring-necked Duck*
Anseriformes Anatidae *Aythya collaris*

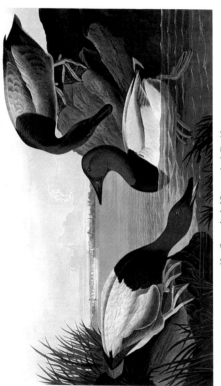

68 *Canvasback* [Canvass-back Duck]
Anseriformes Anatidae *Aythya valisineria*

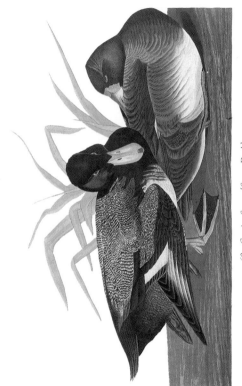

69 *Greater Scaup [Scaup Duck]*
Anseriformes Anatidae *Aythya marila*

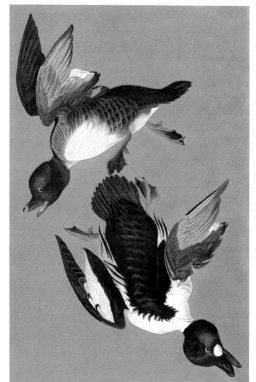

70 *Common Goldeneye [Golden-eye Duck]*
Anseriformes Anatidae *Bucephala clangula*

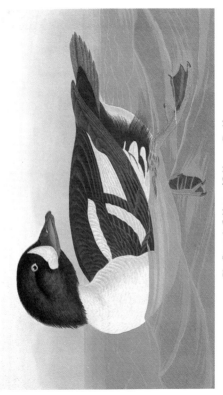

71 *Barrow's Goldeneye [Golden-eye Duck]*
Anseriformes Anatidae *Bucephala islandica*

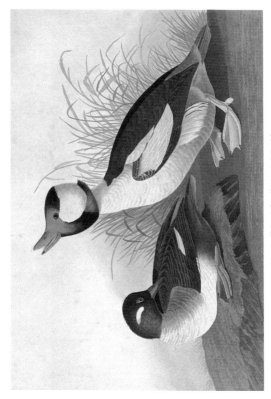

72 *Bufflehead* [Buffel-headed Duck]
Anseriformes Anatidae *Bucephala albeola*

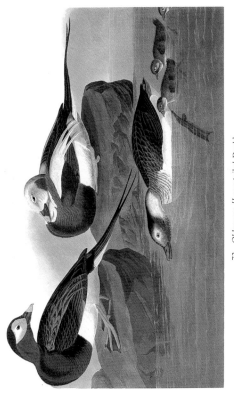

73 *Oldsquaw [Long-tailed Duck]*
Anseriformes Anatidae *Clangula hyemalis*

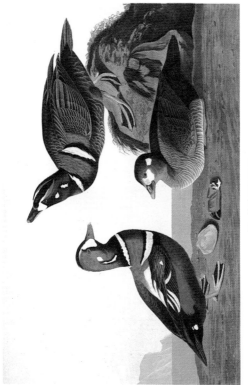

74 *Harlequin Duck*
Anseriformes Anatidae *Histrionicus histrionicus*

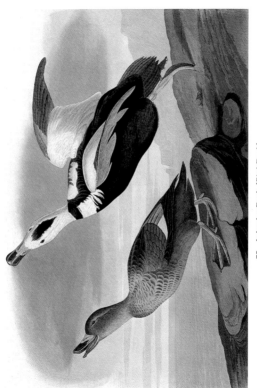

75 *Labrador Duck [Pied Duck]*
Anseriformes Anatidae *Camptorhynchus labradorius*

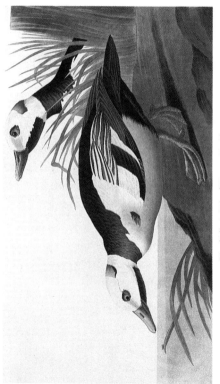

76 *Steller's Eider* [Western Duck]
Anseriformes Anatidae *Polysticta stelleri*

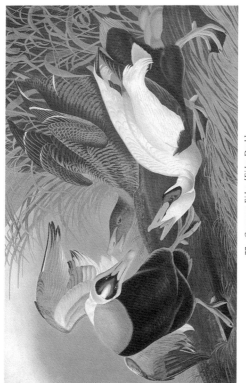

77 *Common Eider* [Eider Duck]
Anseriformes Anatidae *Somateria mollissima*

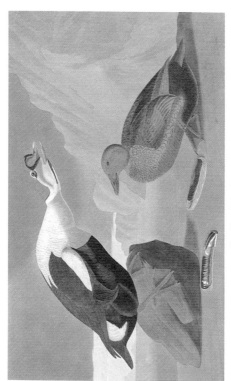

78 *King Eider [King Duck]*
Anseriformes Anatidae *Somateria spectabilis*

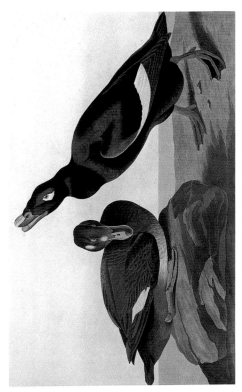

79 *White-winged Scoter [Velvet Duck]*
Anseriformes Anatidae *Melanitta fusca*

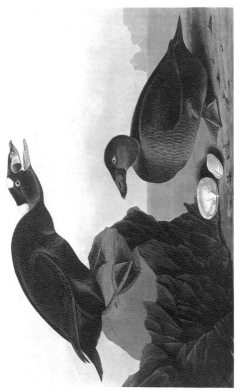

80 *Surf Scoter* [Surf Duck]
Anseriformes Anatidae *Melanitta perspicillata*

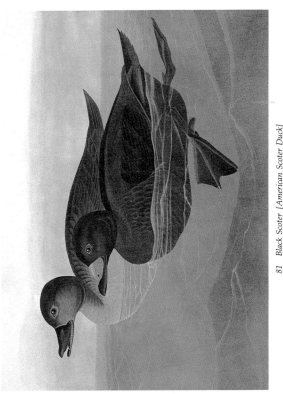

81 *Black Scoter [American Scoter Duck]*
Anseriformes Anatidae *Melanitta nigra*

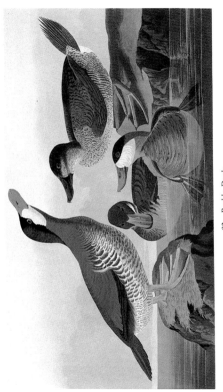

82 *Ruddy Duck*
Anseriformes Anatidae *Oxyura jamaicensis*

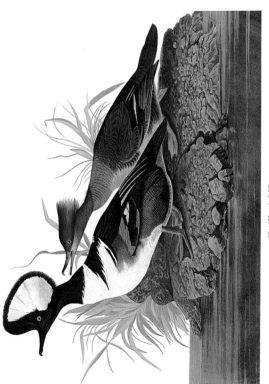

83 *Hooded Merganser*
Anseriformes Anatidae *Lophodytes cucullatus*

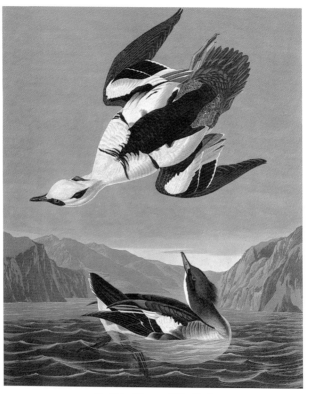

84 *Smew [Smew or White Nun]*
Anseriformes Anatidae *Mergellus albellus*

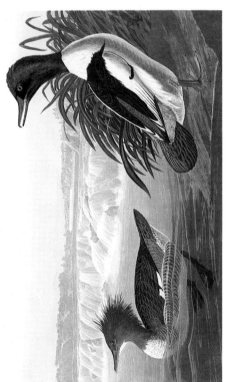

85 *Common Merganser [Goosander]*
Anseriformes Anatidae *Mergus merganser*

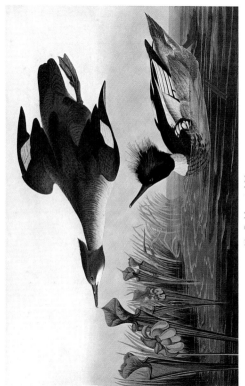

86 *Red-breasted Merganser*
Anseriformes Anatidae *Mergus serrator*

III

SCAVENGERS AND BIRDS OF PREY

Vultures, Kites, Hawks, Eagles,

Harriers, Osprey, Caracaras, and Falcons

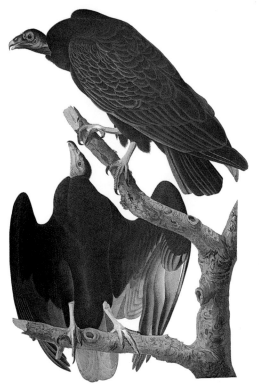

87 *Turkey Vulture [Turkey Buzzard]*
Falconiformes Cathartidae *Cathartes aura*

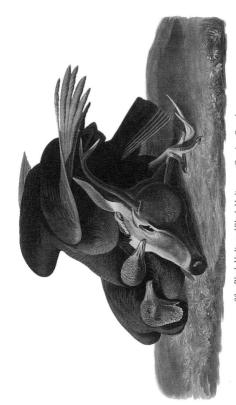

88 Black Vulture [Black Vulture or Carrion Crow]
Falconiformes Cathartidae *Coragyps atratus*

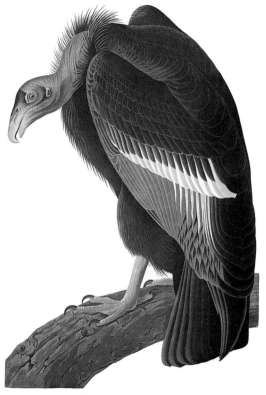

89 California Condor [Californian Vulture]
Falconiformes Cathartidae *Gymnogyps californianus*

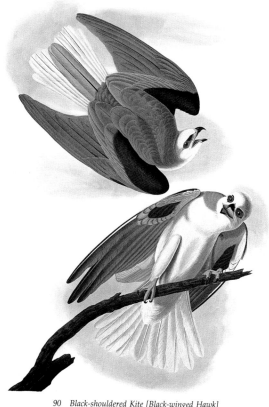

90 Black-shouldered Kite [Black-winged Hawk]
Falconiformes Accipitridae *Elanus caeruleus*

91 *American Swallow-tailed Kite [Swallow-tailed Hawk]*
Falconiformes Accipitridae *Elanoides forficatus*

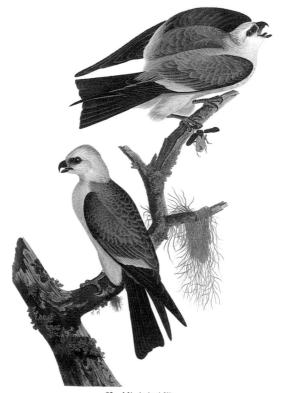

92 *Mississippi Kite*
Falconiformes Accipitridae *Ictinia mississippiensis*

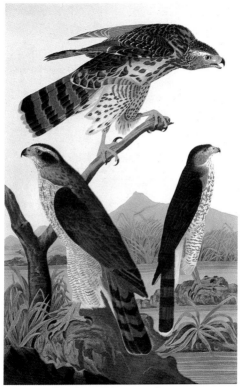

93 Northern Goshawk [Goshawk]
Falconiformes Accipitridae *Accipiter gentilis*

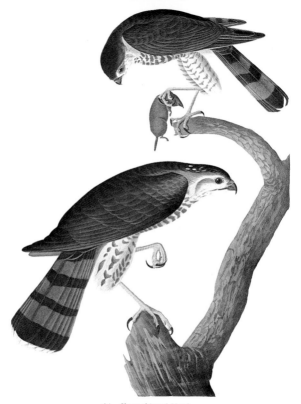

94 *Sharp-shinned Hawk*
Falconiformes Accipitridae *Accipiter striatus*

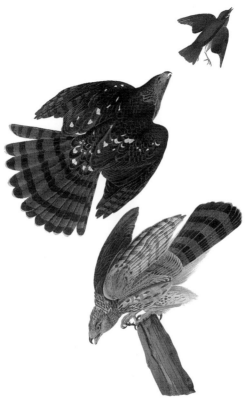

95 Cooper's Hawk [Stanley Hawk]
Falconiformes Accipitridae *Accipiter cooperii*

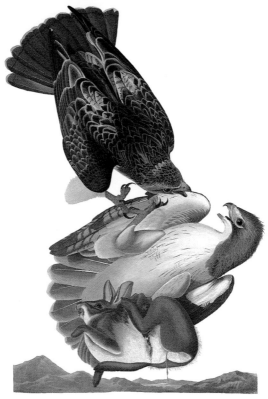

96 Red-tailed Hawk
Falconiformes Accipitridae *Buteo jamaicensis*

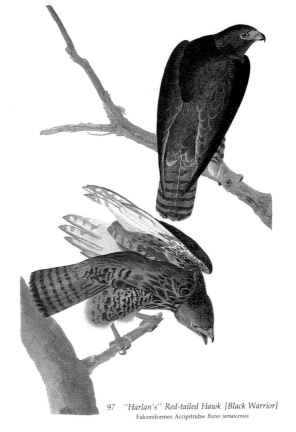

97 *"Harlan's" Red-tailed Hawk [Black Warrior]*
Falconiformes Accipitridae *Buteo jamaicensis*

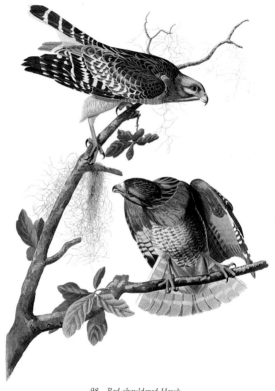

98 Red-shouldered Hawk
Falconiformes Accipitridae *Buteo lineatus*

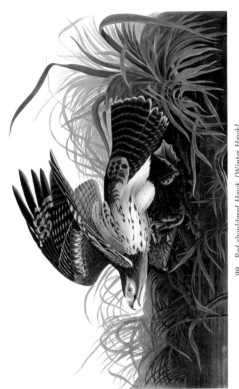

99 *Red-shouldered Hawk [Winter Hawk]*
Falconiformes Accipitridae *Buteo lineatus*

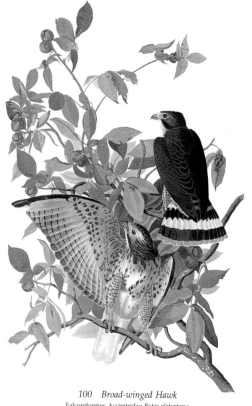

100 Broad-winged Hawk
Falconiformes Accipitridae *Buteo platypterus*

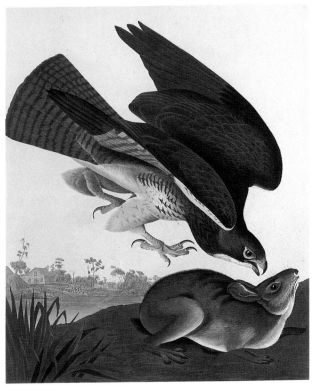

101 *Swainson's Hawk [Common Buzzard]*
Falconiformes Accipitridae *Buteo swainsoni*

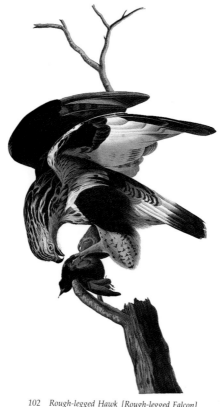

102 Rough-legged Hawk [Rough-legged Falcon]
Falconiformes Accipitridae *Buteo lagopus*

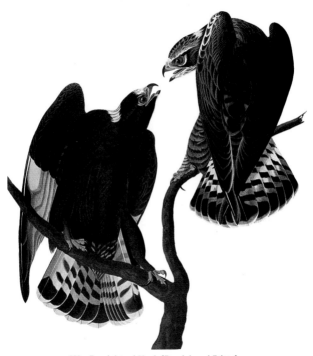

103 *Rough-legged Hawk [Rough-legged Falcon]*
Falconiformes Accipitridae *Buteo lagopus*

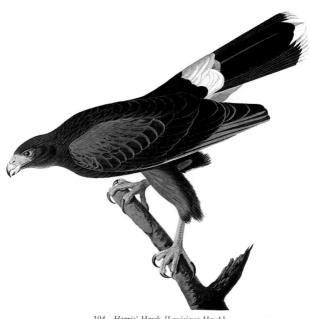

104 *Harris' Hawk [Louisiana Hawk]*
Falconiformes Accipitridae *Parabuteo unicinctus*

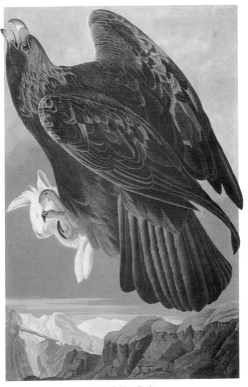

Falconiformes Accipitridae *Aquila chrysaetos*

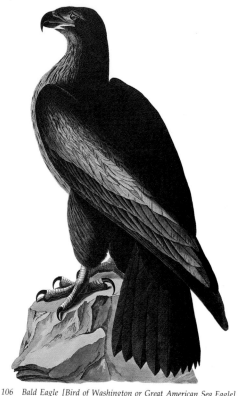

106 Bald Eagle [Bird of Washington or Great American Sea Eagle]
Falconiformes Accipitridae *Haliaeetus leucocephalus*

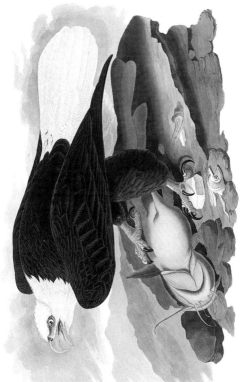

107 *Bald Eagle* [White-headed Eagle]
Falconiformes Accipitridae *Haliaeetus leucocephalus*

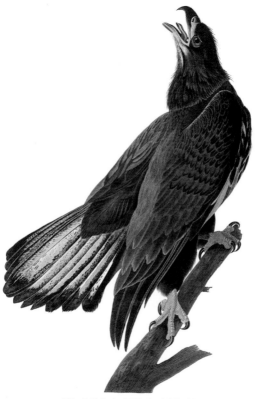

108 Bald Eagle [White-headed Eagle]
Falconiformes Accipitridae *Haliaeetus leucocephalus*

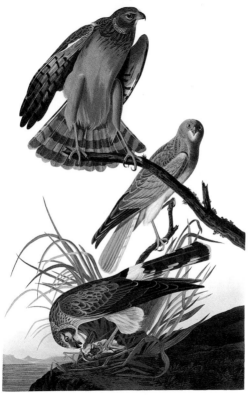

109 *Northern Harrier [Marsh Hawk]*
Falconiformes Accipitridae *Circus cyaneus*

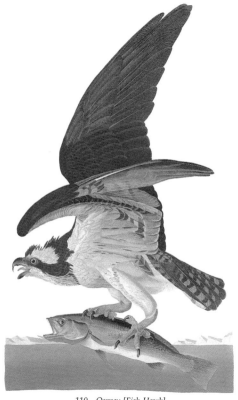

110 Osprey [Fish Hawk]
Falconiformes Accipitridae *Pandion haliaetus*

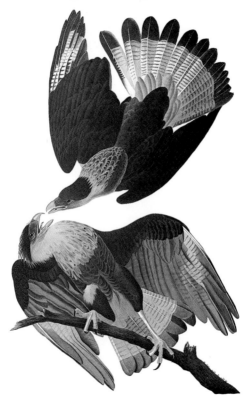

111 *Crested Caracara [Brazilian Caracara Eagle]*
Falconiformes Falconidae *Caracara plancus*

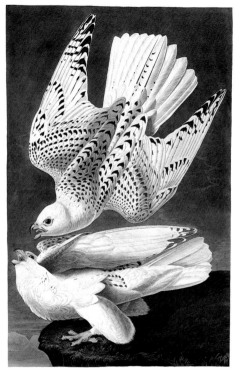

112 Gyrfalcon [Iceland or Jer Falcon]
Falconiformes Falconidae *Falco rusticolus*

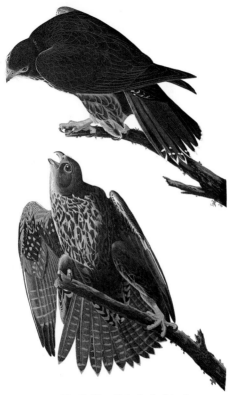

113 *Gyrfalcon [Labrador Jer Falcon]*
Falconiformes Falconidae *Falco rusticolus*

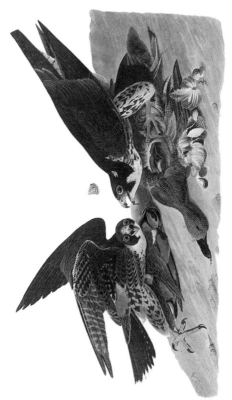

114 *Peregrine Falcon [Great-footed Hawk]*
Falconiformes Falconidae *Falco peregrinus*

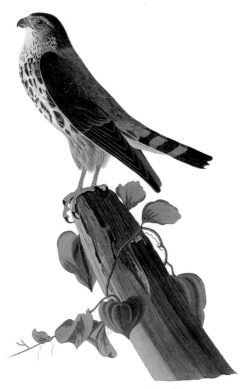

115 Merlin *[Le Petit Caporal]*

Falconiformes Falconidae *Falco columbarius*

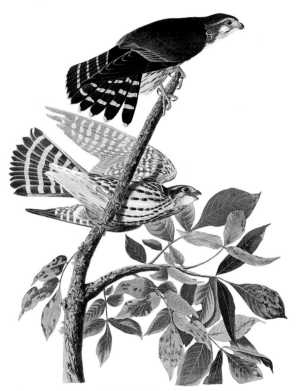

116 *Merlin [Pigeon Hawk]*
Falconiformes Falconidae *Falco columbarius*

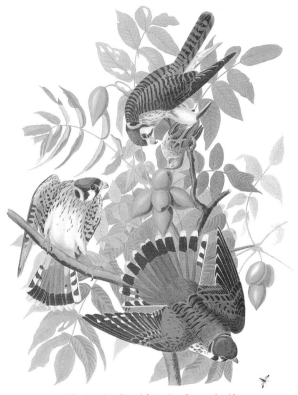

117 *American Kestrel [American Sparrow hawk]*
Falconiformes Falconidae *Falco sparverius*

IV

UPLAND GAMEBIRDS AND

MARSH-DWELLERS

Grouse, Ptarmigan, Quails, Turkeys, Cranes,

Limpkins, Rails, Gallinules, and Coots

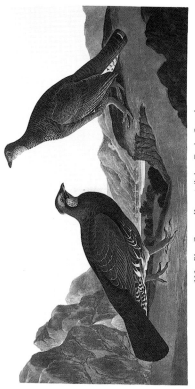

118 *Blue Grouse [Long-tailed or Dusky Grous]*
Galliformes Phasianidae *Dendragapus obscurus*

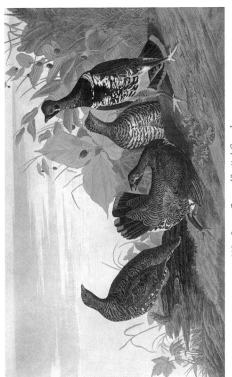

119 *Spruce Grouse [Spotted Grouse]*
Galliformes Phasianidae *Dendragapus canadensis*

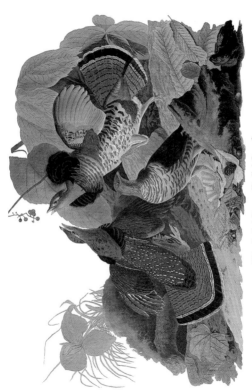

120 *Ruffed Grouse [Ruffed Grous]*
Galliformes Phasianidae *Bonasa umbellus*

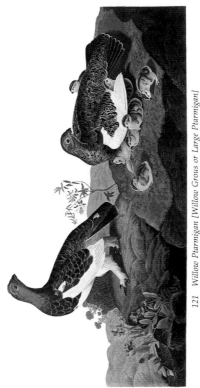

121 *Willow Ptarmigan [Willow Grous or Large Ptarmigan]*
Galliformes Phasianidae *Lagopus lagopus*

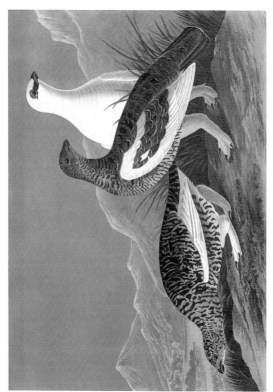

122 *Rock Ptarmigan [Rock Grous]*
Galliformes Phasianidae *Lagopus mutus*

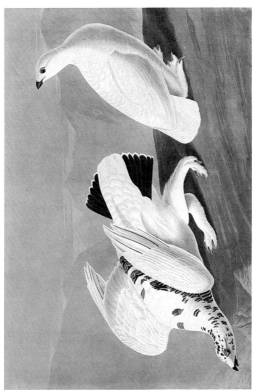

123 *Rock Ptarmigan* [American Ptarmigan] *White-tailed Ptarmigan* [White-tailed Grous]
Galliformes Phasianidae *Lagopus mutus* Galliformes Phasianidae *Lagopus leucurus*

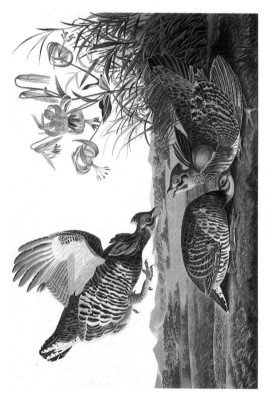

124 *Greater Prairie Chicken* [Pinnated Grous]
Galliformes Phasianidae *Tympanuchus cupido*

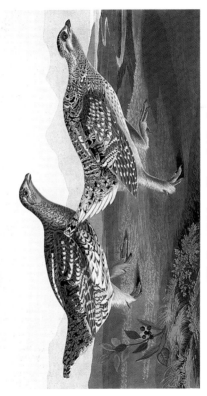

125 *Sharp-tailed Grouse [Sharp-tailed Grous]*
Galliformes Phasianidae *Tympanuchus phasianellus*

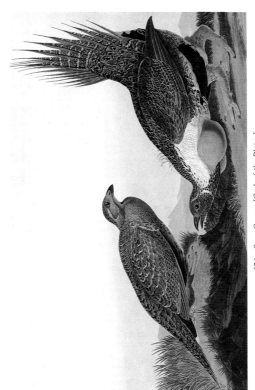

126 *Sage Grouse [Cock of the Plains]*
Galliformes Phasianidae *Centrocercus urophasianus*

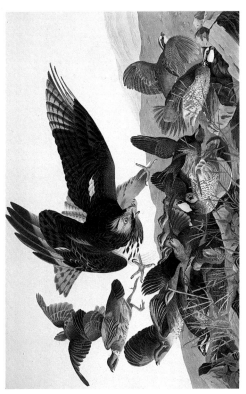

127 *Northern Bobwhite* [*Virginian Partridge*]
Galliformes Phasianidae *Colinus virginianus*

Red-shouldered Hawk [*Red-shouldered Buzzard*]
Falconiformes Accipitridae *Buteo lineatus*

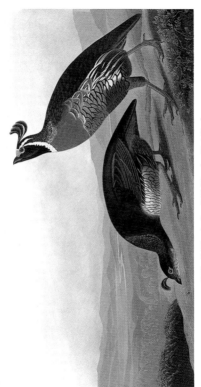

128 California Quail [Californian Partridge]
Galliformes Phasianidae Callipepla californicus

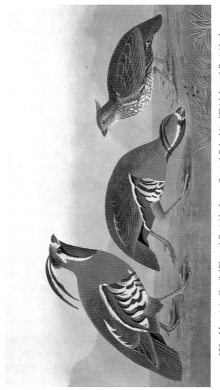

129 Mountain Quail [Plumed Partridge] Crested Bobwhite [Thick-legged Partridge]
Galliformes Phasianidae *Oreortyx pictus* Galliformes Phasianidae *Colinus cristatus*

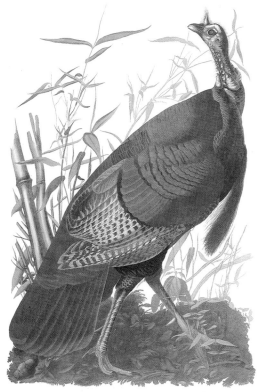

130 Wild Turkey [Great American Cock]
Galliformes Phasianidae *Meleagris gallopavo*

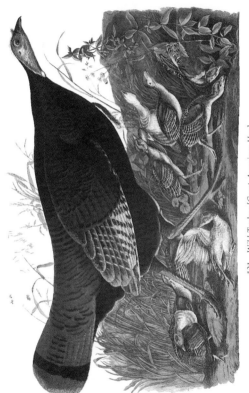

131 *Wild Turkey [Great American Hen]*
Galliformes Phasianidae *Meleagris gallopavo*

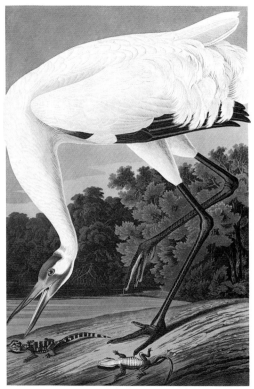

132 Whooping Crane [Hooping Crane]
Gruiformes Gruidae *Grus americana*

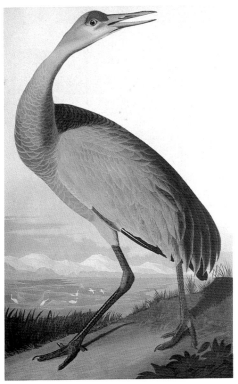

133 Sandhill Crane [Hooping Crane]
Gruiformes Gruidae *Grus canadensis*

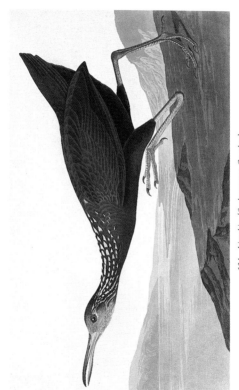

134 *Limpkin* [*Scolopaceous Courlan*]
Gruiformes Aramidae *Aramus guarauna*

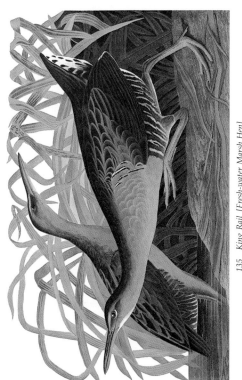

135 *King Rail [Fresh-water Marsh Hen]*
Gruiformes Rallidae *Rallus elegans*

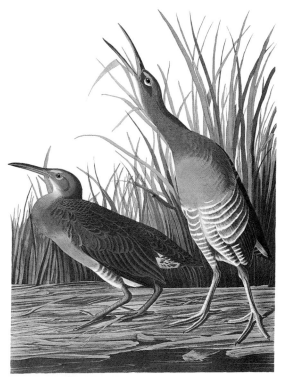

136 *Clapper Rail [Salt-water Marsh Hen]*
Gruiformes Rallidae *Rallus longirostris*

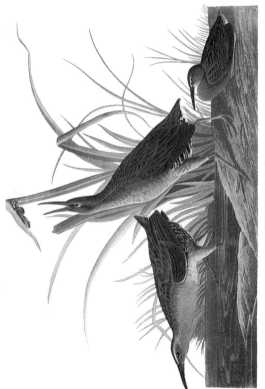

137 *Virginia Rail*
Gruiformes Rallidae *Rallus limicola*

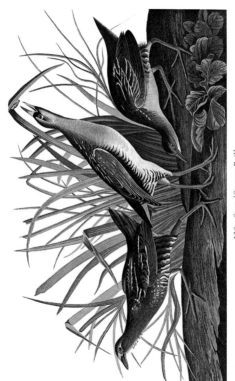

138 *Sora [Sora or Rail]*
Gruiformes Rallidae *Porzana carolina*

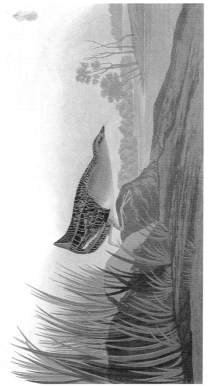

139 *Yellow Rail* [Yellow-breasted Rail]
Gruiformes Rallidae *Coturnicops noveboracensis*

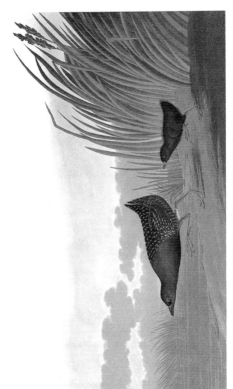

140 Black Rail [Least Water-hen]
Gruiformes Rallidae *Laterallus jamaicensis*

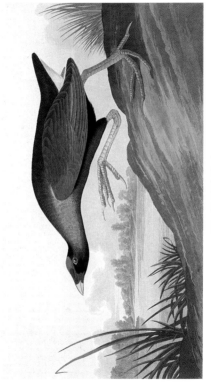

141 *Purple Gallinule*
Gruiformes Rallidae *Porphyrula martinica*

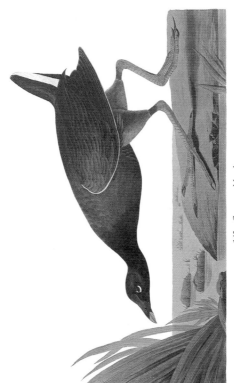

142 *Common Moorhen*
Gruiformes Rallidae *Gallinula chloropus*

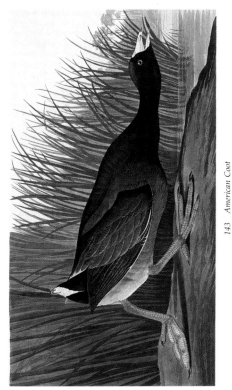

143 *American Coot*
Gruiformes Rallidae *Fulica americana*

V

SHOREBIRDS

Oystercatchers, Stilts, Avocets,
Plovers, Sandpipers, and Phalaropes

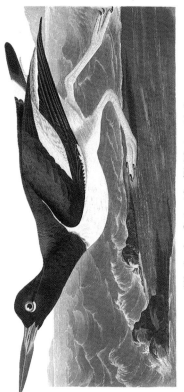

144 *American Oystercatcher* [Pied Oyster-catcher]
Charadriiformes Haematopodidae *Haematopus palliatus*

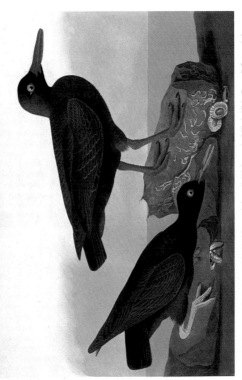

145 *Black Oystercatcher [Bachman's or White-legged Oyster-catcher]*
Charadriiformes Haematopodidae *Haematopus bachmani*

Blackish Oystercatcher ? [Slender-billed or Townsend's Oyster-catcher]
Charadriiformes Haematopodidae *Haematopus ater* ?

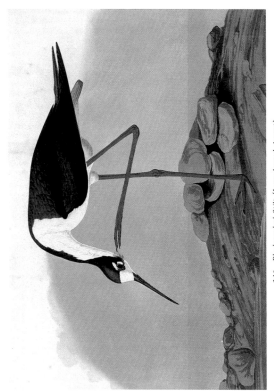

146 *Black-necked Stilt [Long-legged Avocet]*
Charadriiformes Recurvirostridae *Himantopus mexicanus*

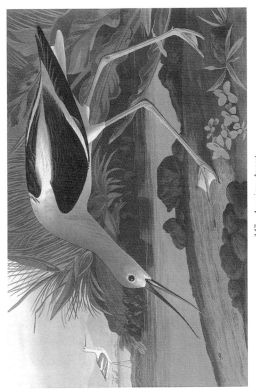

147 *American Avocet*
Charadriiformes Recurvirostridae *Recurvirostra americana*

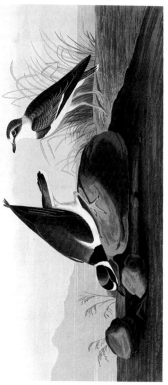

148 *Semipalmated Plover [Ring Plover]*
Charadriiformes Charadriidae *Charadrius semipalmatus*

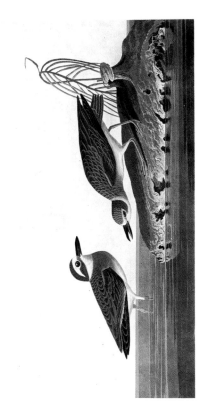

149 *Wilson's Plover*
Charadriiformes Charadriidae *Charadrius wilsonia*

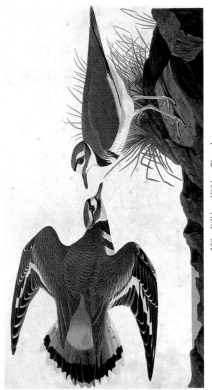

150 *Killdeer [Killdeer Plover]*
Charadriiformes Charadriidae *Charadrius vociferus*

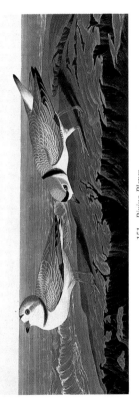

151　*Piping Plover*
Charadriiformes Charadriidae *Charadrius melodus*

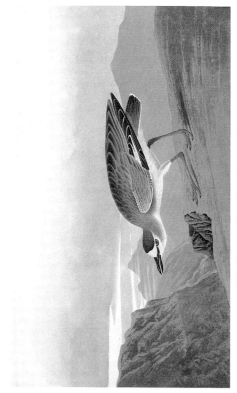

152 *Mountain Plover [Rocky Mountain Plover]*
Charadriiformes Charadriidae *Charadrius montanus*

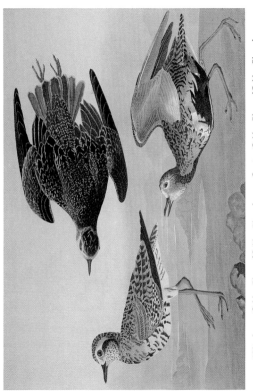

153 *Lesser Golden Plover* [Golden Plover]
Charadriiformes Charadriidae *Pluvialis dominica*

Greater Golden Plover [Golden Plover]
Charadriiformes Charadriidae *Pluvialis apricaria*

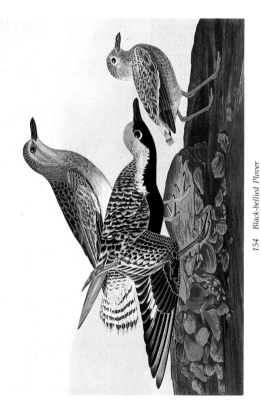

154 *Black-bellied Plover*
Charadriiformes Charadriidae *Pluvialis squatarola*

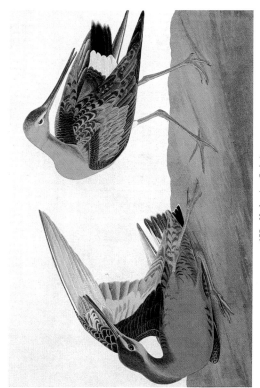

155 *Hudsonian Godwit*
Charadriiformes Scolopacidae *Limosa haemastica*

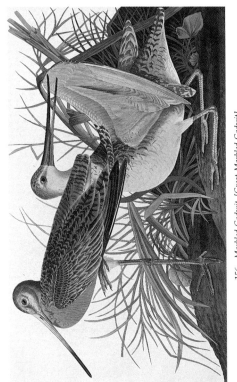

156 *Marbled Godwit [Great Marbled Godwit]*
Charadriiformes Scolopacidae *Limosa fedoa*

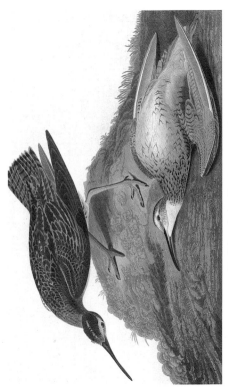

157 *Eskimo Curlew [Esquimaux Curlew]*
Charadriiformes Scolopacidae *Numenius borealis*

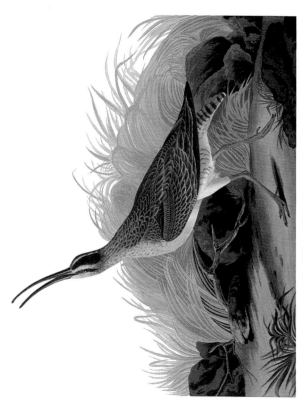

158 *Whimbrel [Great Esquimaux Curlew]*
Charadriiformes Scolopacidae *Numenius phaeopus*

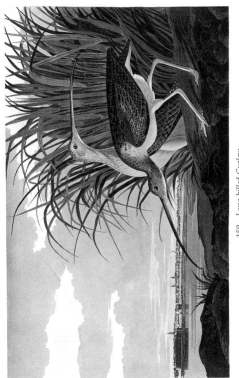

159 *Long-billed Curlew*
Charadriiformes Scolopacidae *Numenius americanus*

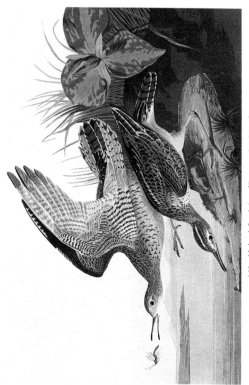

160 *Upland Sandpiper* [*Bartram Sandpiper*]
Charadriiformes Scolopacidae *Bartramia longicauda*

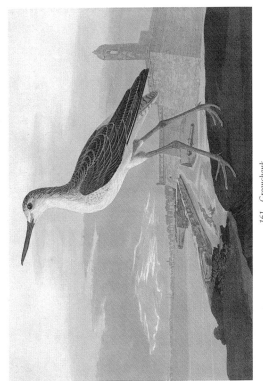

161 *Greenshank*
Charadriiformes Scolopacidae *Tringa nebularia*

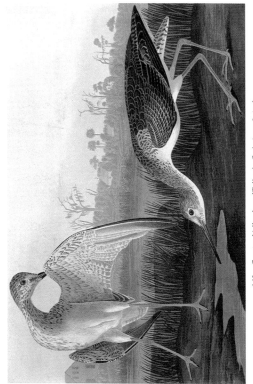

162 *Greater Yellowlegs [Tell-tale Godwit or Snipe]*
Charadriiformes Scolopacidae *Tringa melanoleuca*

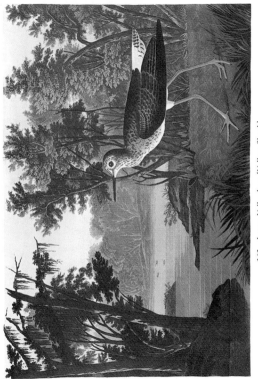

163 Lesser Yellowlegs [Yellow Shank]
Charadriiformes Scolopacidae *Tringa flavipes*

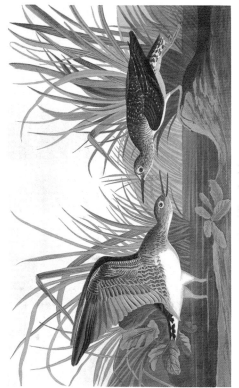

164 *Solitary Sandpiper*
Charadriiformes Scolopacidae *Tringa solitaria*

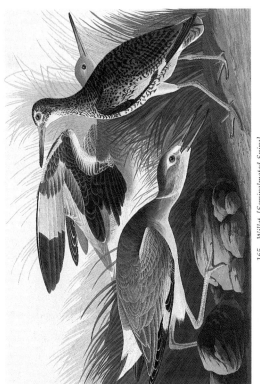

165 Willet [Semipalmated Snipe]
Charadriiformes Scolopacidae *Catoptrophorus semipalmatus*

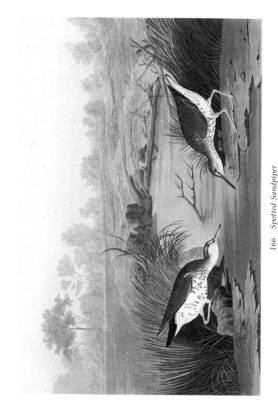

166 *Spotted Sandpiper*
Charadriiformes Scolopacidae *Actitis macularia*

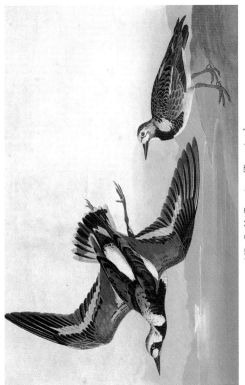

167 *Ruddy Turnstone* [Turn-stone]
Charadriiformes Scolopacidae *Arenaria interpres*

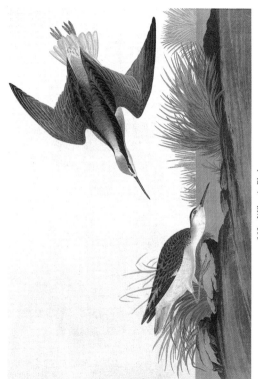

168 *Wilson's Phalarope*
Charadriiformes Scolopacidae *Phalaropus tricolor*

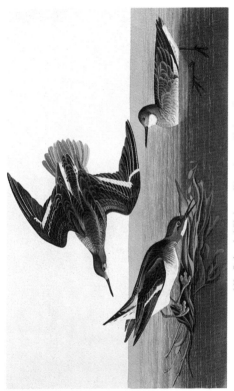

169 *Red-necked Phalarope [Hyperborean Phalarope]*
Charadriiformes Scolopacidae *Phalaropus lobatus*

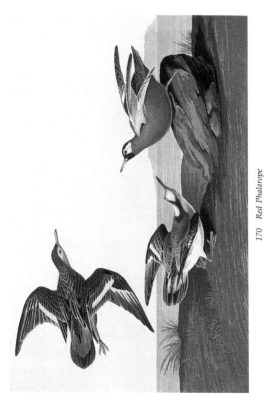

170 *Red Phalarope*
Charadriiformes Scolopacidae *Phalaropus fulicaria*

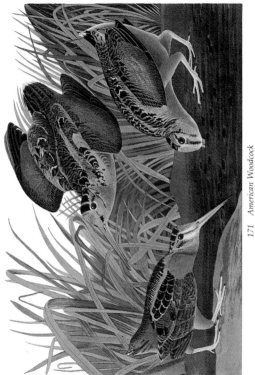

171 *American Woodcock*
Charadriiformes Scolopacidae *Philohela minor*

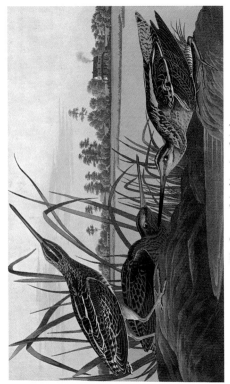

172 *Common Snipe [American Snipe]*
Charadriiformes Scolopacidae *Gallinago gallinago*

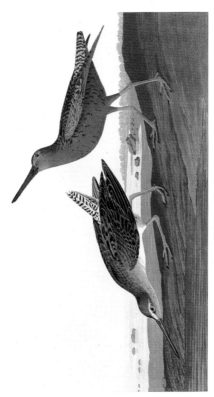

173 *Short-billed Dowitcher* [*Red-breasted Snipe*]
Charadriiformes Scolopacidae *Limnodromus griseus*

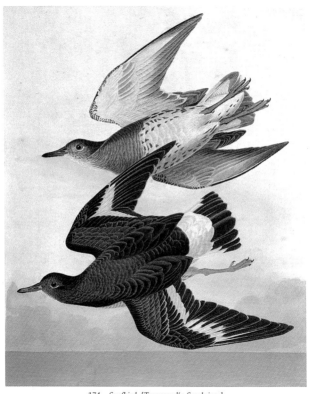

174 *Surfbird [Townsend's Sandpiper]*
Charadriiformes Scolopacidae *Aphriza virgata*

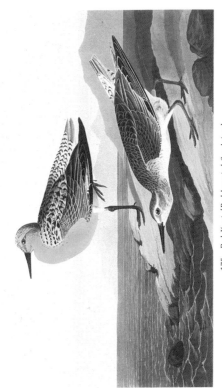

175 *Red Knot* [Red-breasted Sandpiper]
Charadriiformes Scolopacidae *Calidris canutus*

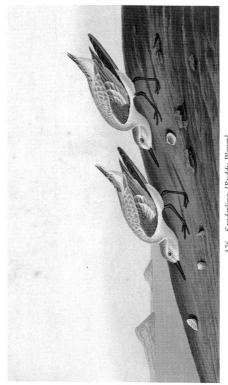

176 *Sanderling [Ruddy Plover]*
Charadriiformes Scolopacidae *Calidris alba*

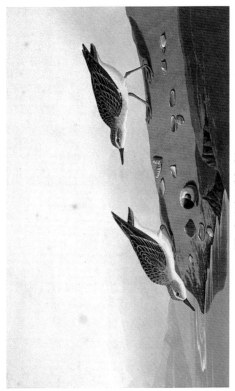

177 *Semipalmated Sandpiper*
Charadriiformes Scolopacidae *Calidris pusilla*

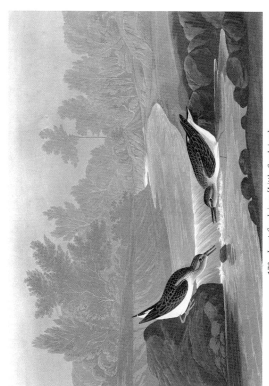

178 *Least Sandpiper* [Little Sandpiper]
Charadriiformes Scolopacidae *Calidris minutilla*
PLEASE NOTE THIS PLATE IS OUT OF PHYLOGENETIC SEQUENCE

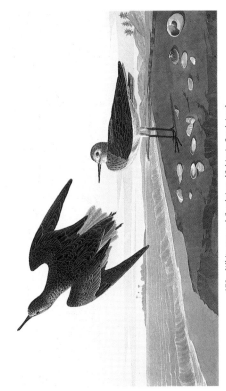

179 *White-rumped Sandpiper* [Schinz's Sandpiper]
Charadriiformes Scolopacidae *Calidris fuscicollis*

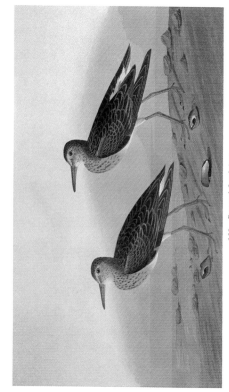

180 *Pectoral Sandpiper*
Charadriiformes Scolopacidae *Calidris melanotos*

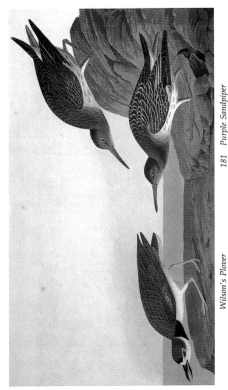

Wilson's Plover
Charadriiformes Charadriidae *Charadrius wilsonia*

181 Purple Sandpiper
Charadriiformes Scolopacidae *Calidris maritima*

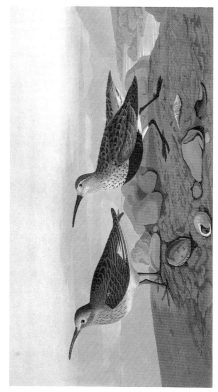

182 *Dunlin* [Red-backed Sandpiper]
Charadriiformes Scolopacidae *Calidris alpina*

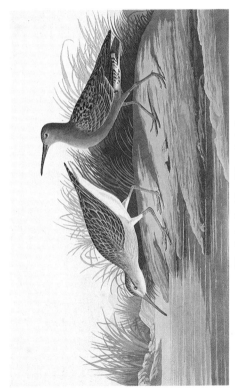

183 *Curlew Sandpiper* [*Pigmy Curlew*]
Charadriiformes Scolopacidae *Calidris ferruginea*

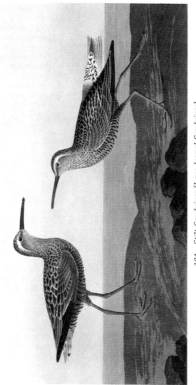

184 *Stilt Sandpiper [Long-legged Sandpiper]*
Charadriiformes Scolopacidae *Calidris himantopus*

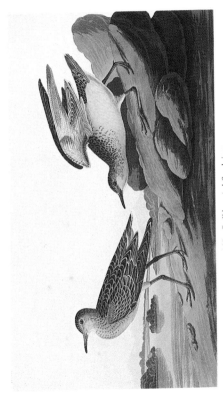

185 *Buff-breasted Sandpiper*
Charadriiformes Scolopacidae *Tryngites subruficollis*

VI

SEABIRDS

Jaegers, Gulls, Terns, Skimmers, and Auks

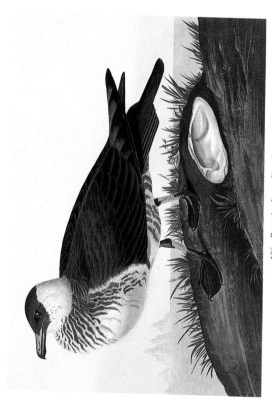

186 *Pomarine Jaeger* [Jager]
Charadriiformes Laridae *Stercorarius pomarinus*

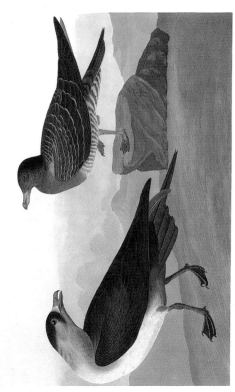

187 *Parasitic Jaeger [Richardson's Jager]*
Charadriiformes Laridae *Stercorarius parasiticus*

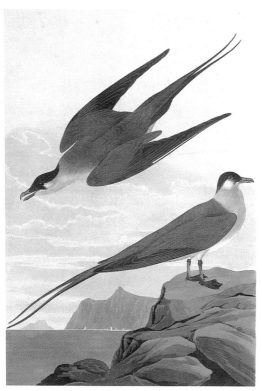

188 Long-tailed Jaeger [Arctic Jager]
Charadriiformes Laridae *Stercorarius longicaudus*

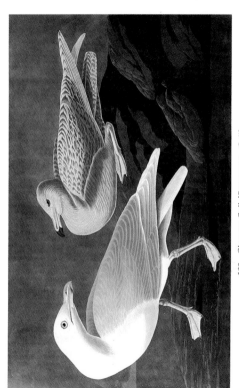

189 *Glaucous Gull [Burgomaster Gull]*
Charadriiformes Laridae *Larus hyperboreus*

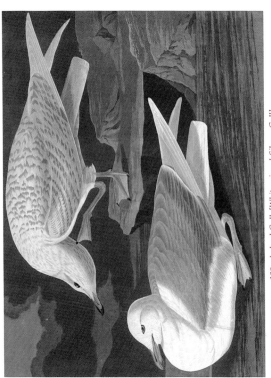

190 *Iceland Gull* [*White-winged Silvery Gull*]
Charadriiformes Laridae *Larus glaucoides*

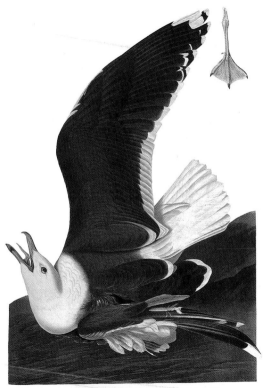

191 *Great Black-backed Gull* [Black-backed Gull]
Charadriiformes Laridae *Larus marinus*

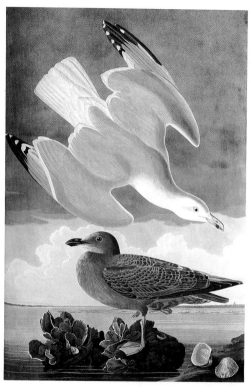

192 Herring Gull
Charadriiformes Laridae *Larus argentatus*

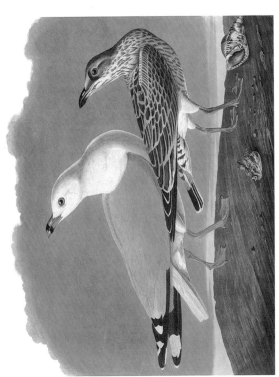

193 *Ring-billed Gull [Common Gull]*
Charadriiformes Laridae *Larus delawarensis*

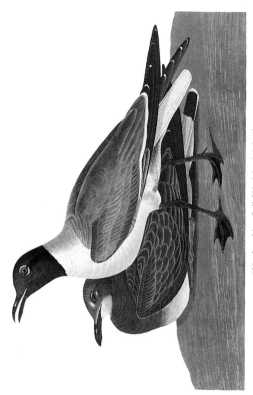

194 *Laughing Gull [Black-headed Gull]*
Charadriiformes Laridae *Larus atricilla*

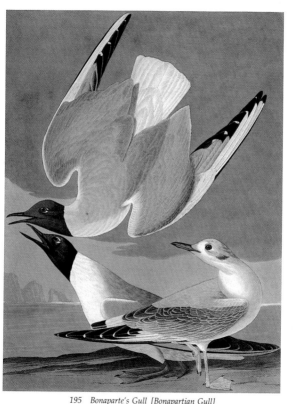

195 *Bonaparte's Gull [Bonapartian Gull]*
Charadriiformes Laridae *Larus philadelphia*

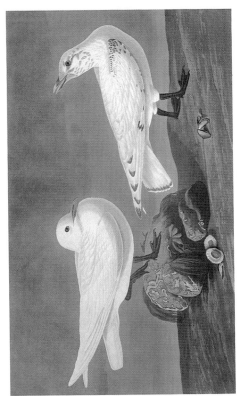

196 *Ivory Gull*
Charadriiformes Laridae *Pagophila eburnea*

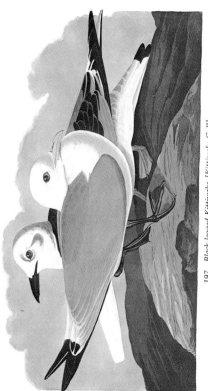

197 *Black-legged Kittiwake [Kittiwake Gull]*
Charadriiformes Laridae *Rissa tridactyla*

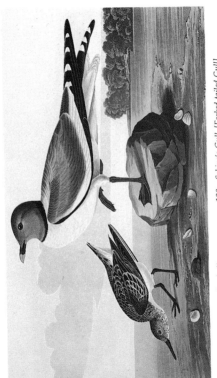

Sanderling
Charadriiformes Scolopacidae *Calidris alba*

198 *Sabine's Gull [Forked-tailed Gull]*
Charadriiformes Laridae *Xema sabini*

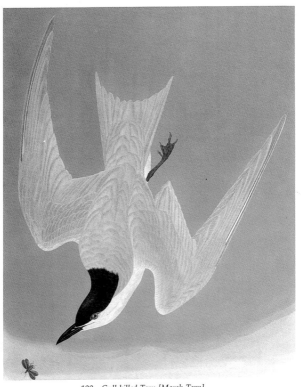

199 *Gull-billed Tern [Marsh Tern]*
Charadriiformes Laridae *Sterna niloctica*

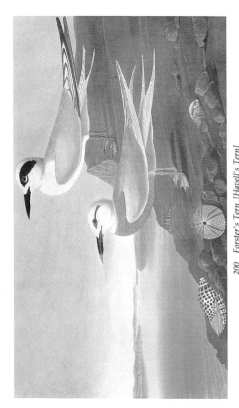

200 *Forster's Tern* [Havell's Tern]
Charadriiformes Laridae *Sterna forsteri*

Trudeau's Tern
Charadriiformes Laridae *Sterna trudeaui*

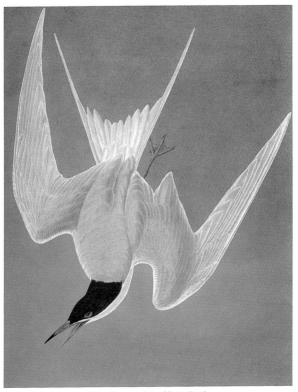

201 Common Tern [Great Tern]
Charadriiformes Laridae *Sterna hirundo*

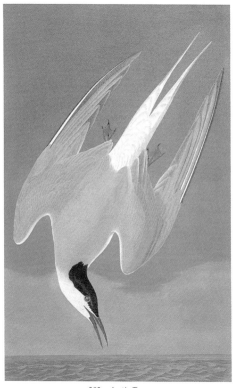

202 Arctic Tern
Charadriiformes Laridae *Sterna paradisaea*

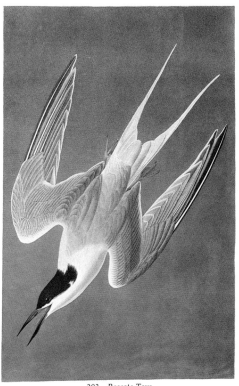

203 Roseate Tern
Charadriiformes Laridae *Sterna dougallii*

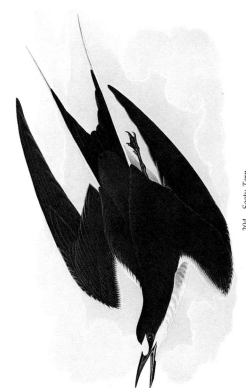

204 *Sooty Tern*
Charadriiformes Laridae *Sterna fuscata*

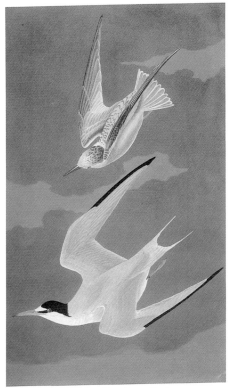

205 Least Tern [Lesser Tern]
Charadriiformes Laridae *Sterna antillarum*

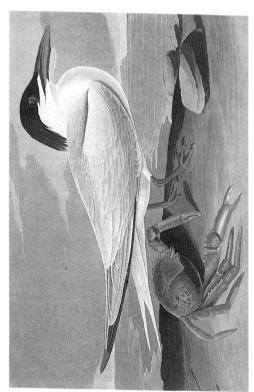

206 *Royal Tern [Cayenne Tern]*
Charadriiformes Laridae *Sterna maxima*

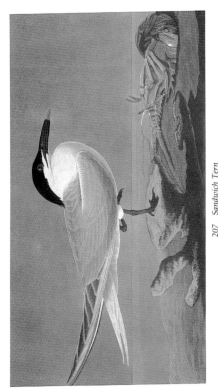

207 *Sandwich Tern*

Charadriiformes Laridae *Sterna sandvicensis*

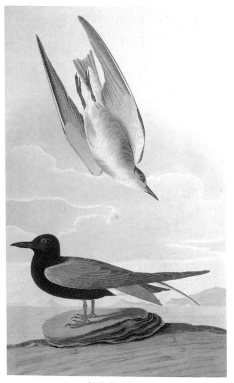

208 Black Tern

Charadriiformes Laridae *Chlidonias niger*

209 *Brown Noddy* [Noddy Tern]
Charadriiformes Laridae *Anous stolidus*

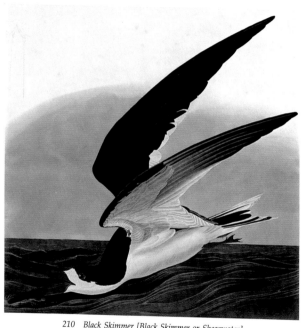

210 *Black Skimmer [Black Skimmer or Shearwater]*
Charadriiformes Laridae *Rynchops niger*

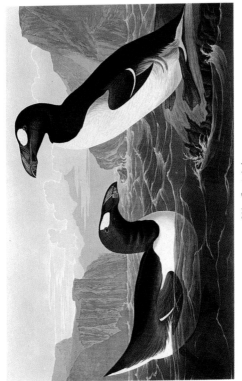

211 *Great Auk*
Charadriiformes Alcidae *Pinguinus impennis*

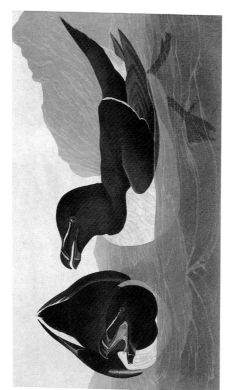

212 *Razorbill* [*Razor Bill*]
Charadriiformes Alcidae *Alca torda*

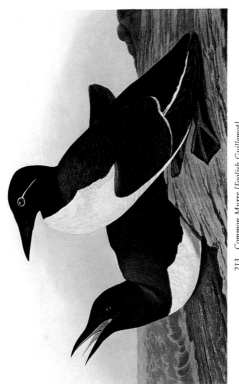

213 *Common Murre* [Foolish Guillemot]
Charadriiformes Alcidae *Uria aalge*

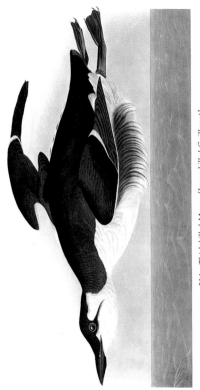

214 *Thick-billed Murre [Large-billed Guillemot]*
Charadriiformes Alcidae *Uria lomvia*

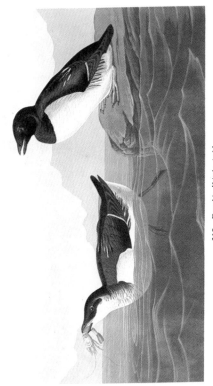

215 *Dovekie [Little Auk]*
Charadriiformes Alcidae *Alle alle*

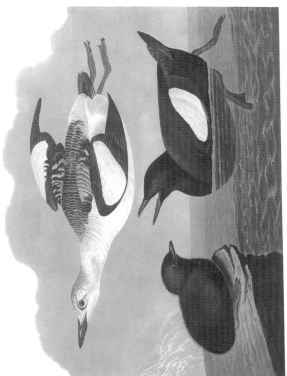

216 *Black Guillemot*
Charadriiformes Alcidae *Cepphus grylle*

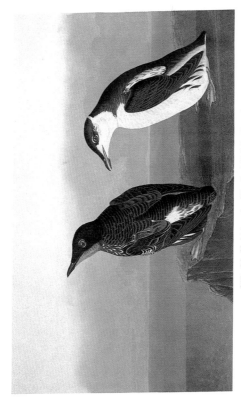

217 *Marbled Murrelet [Slender-billed Guillemot]*
Charadriiformes Alcidae *Brachyramphus marmoratus*

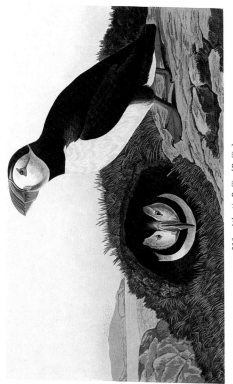

218 *Atlantic Puffin* [Puffin]
Charadriiformes Alcidae *Fratercula arctica*

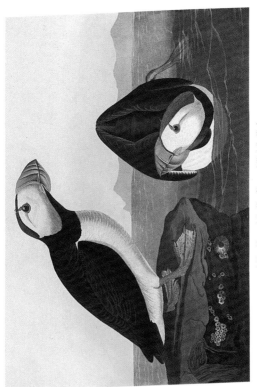

219 *Horned Puffin [Large-billed Puffin]*
Charadriiformes Alcidae *Fratercula corniculata*

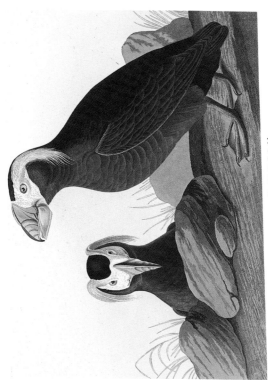

220 *Tufted Puffin [Tufted Auk]*
Charadriiformes Alcidae *Fratercula cirrhata*

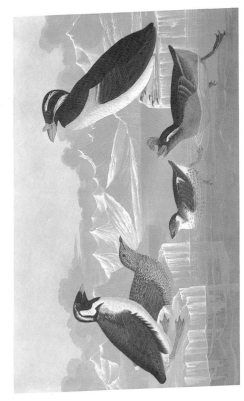

Ancient Murrelet [Black-throated Guillemot]
Charadriiformes Alcidae Synthliboramphus antiquus

Least Auklet [Nobbed-billed Phaleris]
Charadriiformes Alcidae Aethia pusilla

Rhinoceros Auklet [Horned-billed Guillemot]
Charadriiformes Alcidae Cerorhinca monocerata

Marbled Murrelet [Black-throated Guillemot]
Charadriiformes Alcidae Brachyramphus marmoratus

Crested Auklet [Curled-crested Phaleris]
Charadriiformes Alcidae Aethia cristatella

VII

SHOWY BIRDS,
NOCTURNAL HUNTERS,
AND SUPERB AERIALISTS

Pigeons, Parrots, Cuckoos,
Owls, Nightjars, Swifts, and Hummingbirds

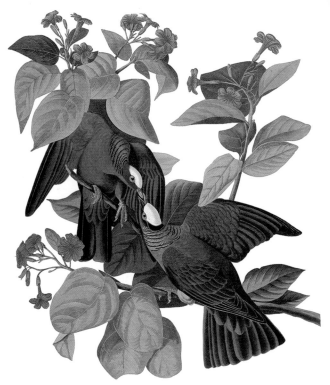

222 *White-crowned Pigeon*
Columbiformes Columbidae *Columba leucocephala*

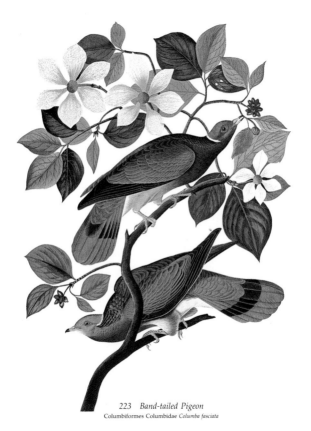

223 *Band-tailed Pigeon*
Columbiformes Columbidae *Columba fasciata*

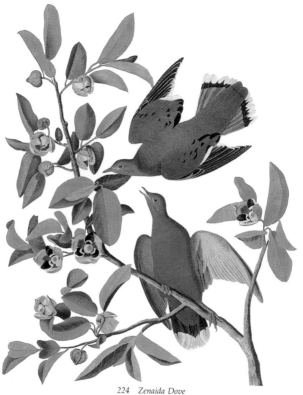

224 *Zenaida Dove*
Columbiformes Columbidae *Zenaida aurita*

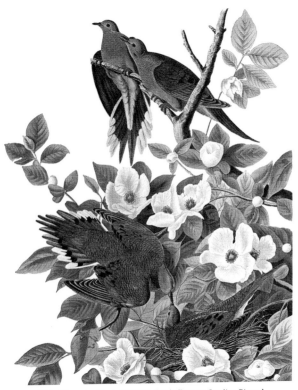

225 *Mourning Dove* [Carolina Turtle Dove or Carolina Pigeon]
Columbiformes Columbidae *Zenaida macroura*

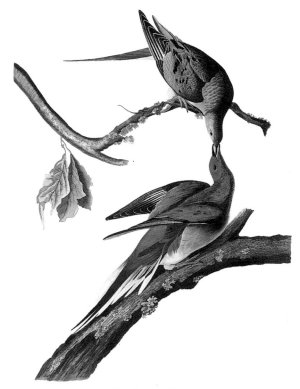

226 *Passenger Pigeon*
Columbiformes Columbidae *Ectopistes migratorius*

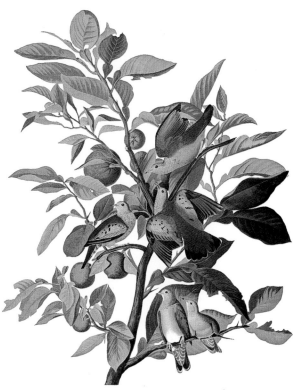

227 *Common Ground Dove [Ground Dove]*

Columbiformes Columbidae *Columbina passerina*

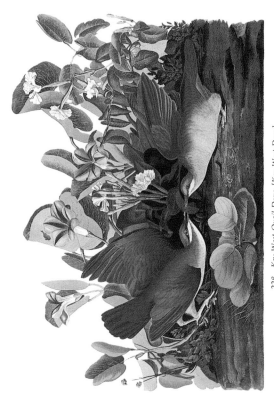

228 *Key West Quail Dove* [Key West Dove]
Columbiformes Columbidae *Geotrygon chrysia*

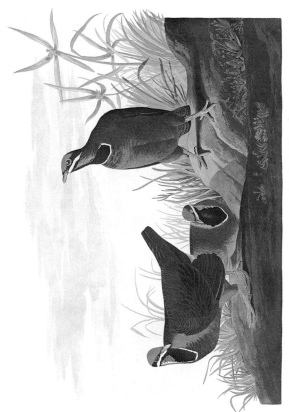

229 *Blue-headed Quail Dove* [*Blue-headed Pigeon*]
Columbiformes Columbidae *Starnoenas cyanocephala*

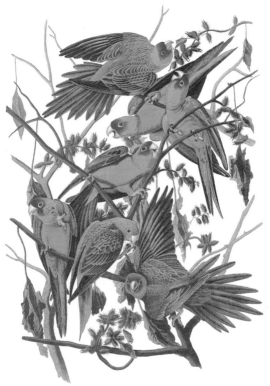

230 Carolina Parakeet [Carolina Parrot]
Psittaciformes Psittacidae *Conuropsis carolinensis*

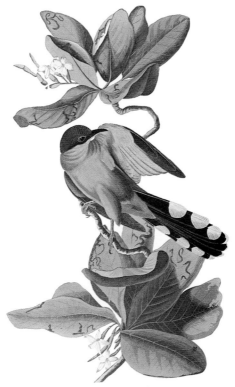

231 *Mangrove Cuckoo*
Cuculiformes Cuculidae *Coccyzus minor*

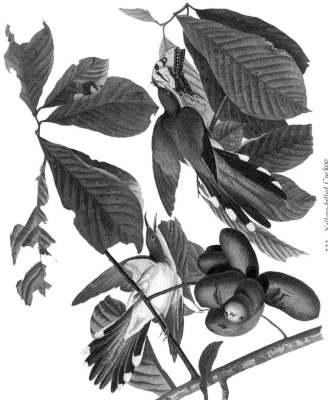

232 *Yellow-billed Cuckoo*
Cuculiformes Cuculidae *Coccyzus americanus*

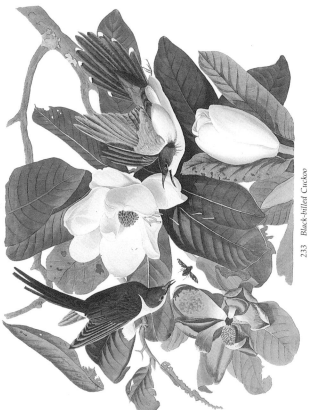

233 *Black-billed Cuckoo*
Cuculiformes Cuculidae *Coccyzus erythropthalmus*

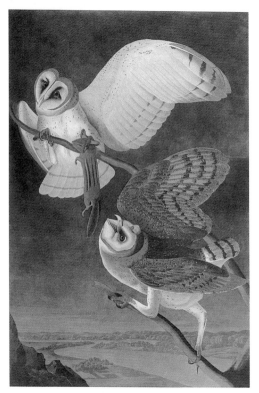

234 Barn Owl
Strigiformes Tytonidae *Tyto alba*

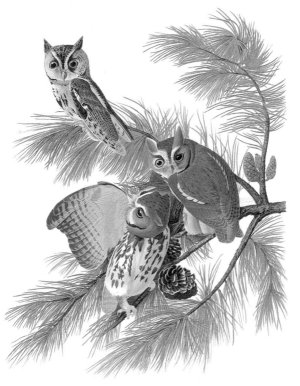

235 *Eastern Screech-Owl [Mottled Owl]*
Strigiformes Strigidae *Otus asio*

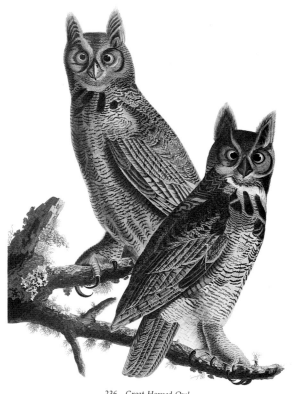

236 *Great Horned Owl*
Strigiformes Strigidae *Bubo virginianus*

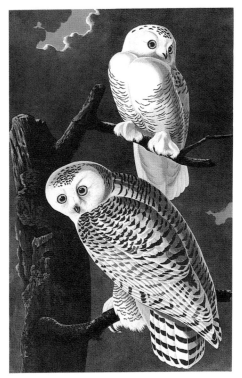

237 Snowy Owl
Strigiformes Strigidae *Nyctea scandiaca*

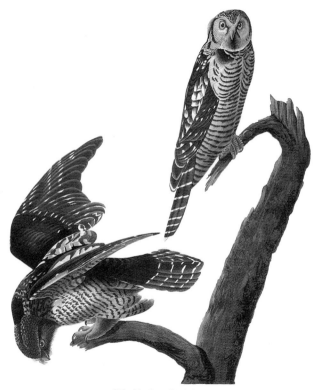

238 Northern Hawk-Owl
Strigiformes Strigidae *Surnia ulula*

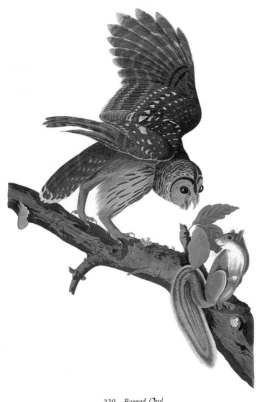

239 Barred Owl
Strigiformes Strigidae *Strix varia*

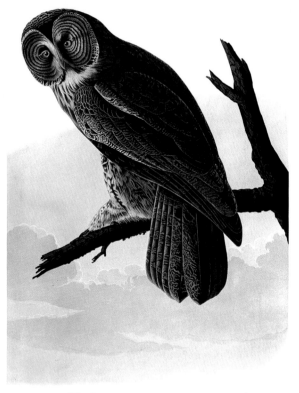

240 *Great Gray Owl* [Great Cinereous Owl]
Strigiformes Strigidae *Strix nebulosa*

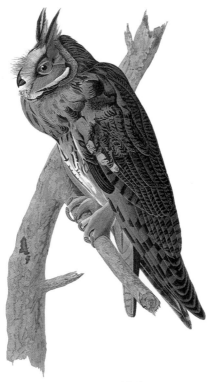

241 Long-eared Owl
Strigiformes Strigidae *Asio otus*

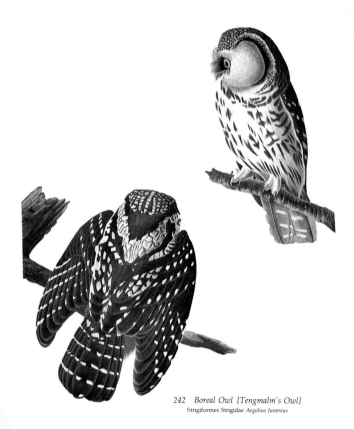

242 Boreal Owl [Tengmalm's Owl]
Strigiformes Strigidae *Aegolius funereus*

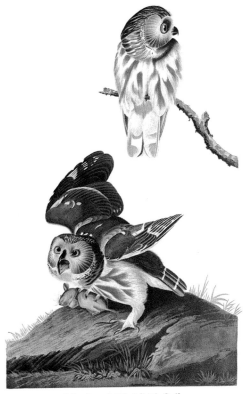

243 Saw-whet Owl [Little Owl]
Strigiformes Strigidae *Aegolius acadicus*

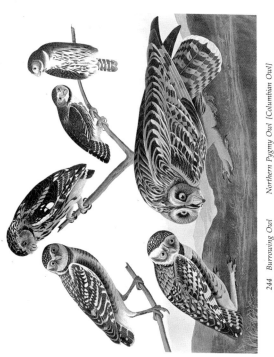

244 Burrowing Owl
[Large-headed Burrowing Owl]
Stringiformes Strigidae Athene cunicularia

Little Owl ? [Little Night Owl]

Northern Pygmy Owl [Columbian Owl]
Stringiformes Strigidae Glaucidium gnoma

Short-eared Owl

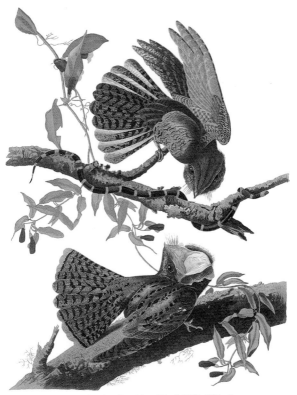

245 *Chuck-will's-widow* [Chuck Will's Widow]
Caprimulgiformes Caprimulgidae *Caprimulgus carolinensis*

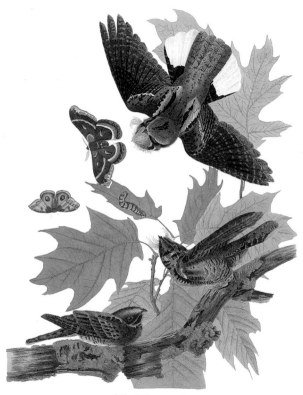

246 Whip-poor-will
Caprimulgiformes Caprimulgidae *Caprimulgus vociferus*

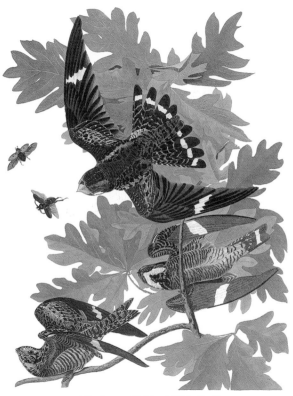

247　*Common Nighthawk [Night Hawk]*
Caprimulgiformes Caprimulgidae *Chordeiles minor*

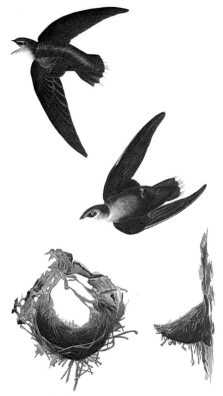

248 Chimney Swift [American Swift]
Apodiformes Apodidae *Chaetura pelagica*

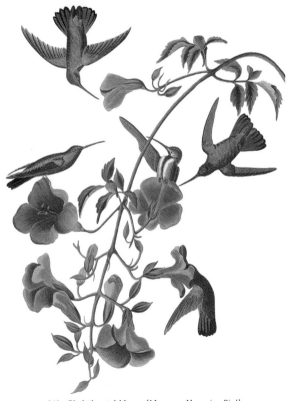

249 *Black-throated Mango [Mangrove Humming Bird]*
Apodiformes Trochilidae *Anthracothorax nigricollis*

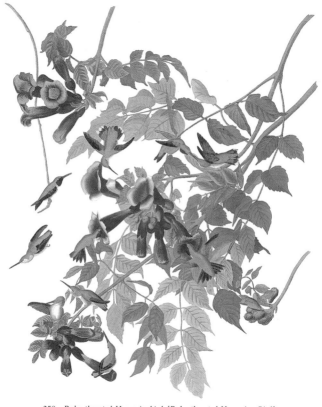

250 *Ruby-throated Hummingbird [Ruby-throated Humming Bird]*
Apodiformes Trochilidae *Archilochus colubris*

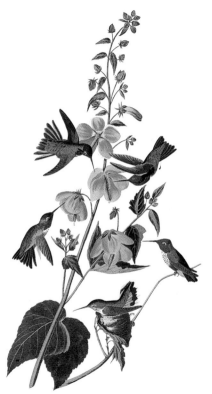

251 *Anna's Hummingbird [Columbian Humming Bird]*
Apodiformes Trochilidae *Calypte anna*

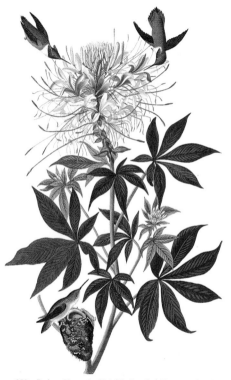

252 *Rufous Hummingbird* [*Ruff-necked Humming-bird*]
Apodiformes Trochilidae *Selasphorus rufus*

VIII

GLEANERS OF FOREST
AND MEADOW

Kingfishers, Woodpeckers, Tyrant Flycatchers, Larks,
Swallows, Jays, Magpies, Crows,
Titmice, and Nuthatches

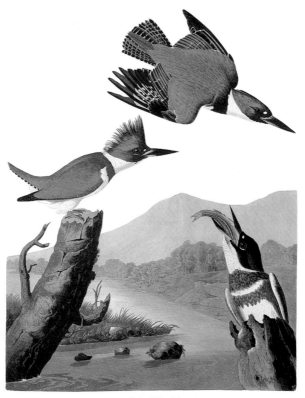

253 *Belted Kingfisher*
Coraciiformes Alcedinidae *Ceryle alcyon*

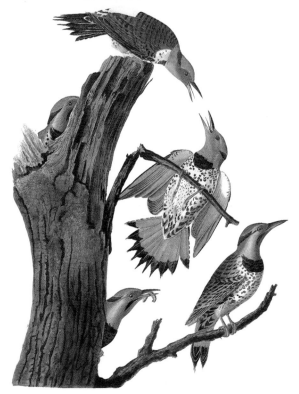

254 *Northern Flicker [Golden-winged Woodpecker]*
Piciformes Picidae *Colaptes auratus*

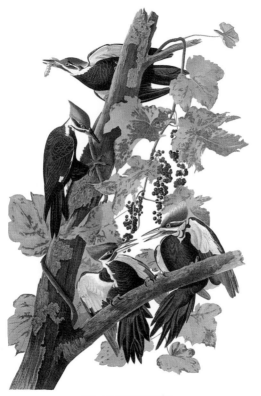

255 *Pileated Woodpecker*
Piciformes Picidae *Dryocopus pileatus*

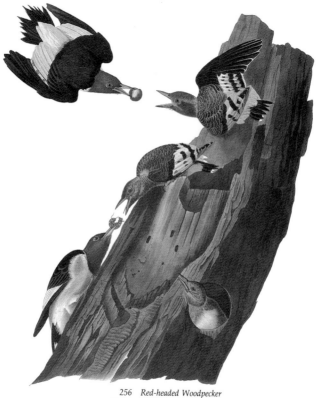

256 *Red-headed Woodpecker*
Piciformes Picidae *Melanerpes erythrocephalus*

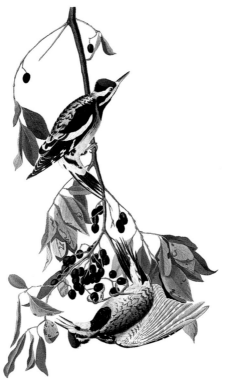

257 *Yellow-bellied Sapsucker [Yellow-bellied Woodpecker]*
Piciformes Picidae *Sphyrapicus varius*

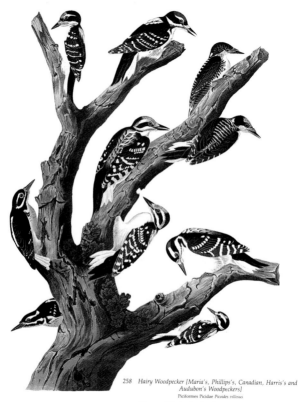

258 Hairy Woodpecker [Maria's, Phillips's, Canadian, Harris's and
Audubon's Woodpeckers]
Piciformes Picidae *Picoides villosus*

Three-toed Woodpecker [Banded Three-toed Woodpecker]
Piciformes Picidae *Picoides tridactylus*

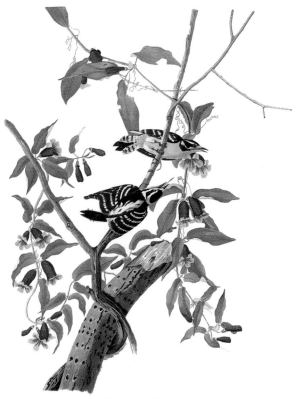

259 *Downy Woodpecker*
Piciformes Picidae *Picoides pubescens*

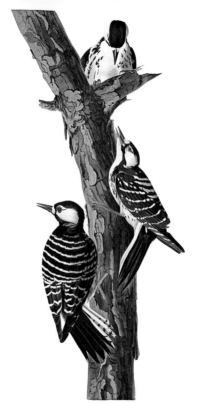

260 Red-cockaded Woodpecker
Piciformes Picidae *Picoides borealis*

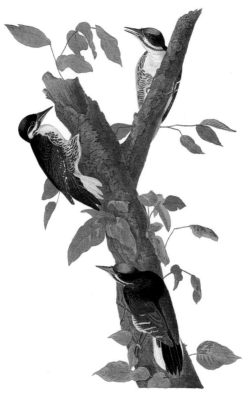

261 Black-backed Woodpecker [Three-toed Woodpecker]
Piciformes Picidae *Picoides arcticus*

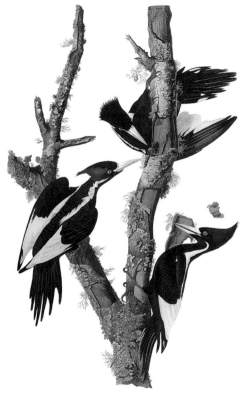

262 *Ivory-billed Woodpecker*
Piciformes Picidae *Campephilus principalis*

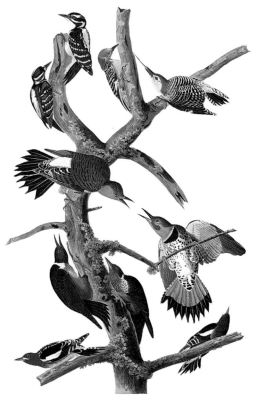

263 *Hairy Woodpecker*
Piciformes Picidae *Picoides villosus*

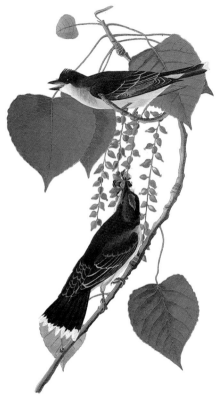

264 *Eastern Kingbird [Tyrant Flycatcher]*
Passeriformes Tyrannidae *Tyrannus tyrannus*

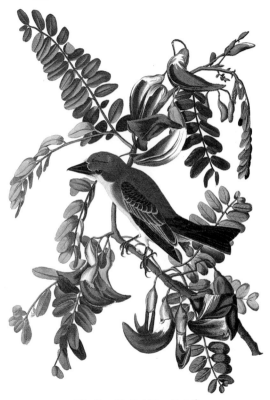

265 *Gray Kingbird [Gray Tyrant]*
Passeriformes Tyrannidae *Tyrannus dominicensis*

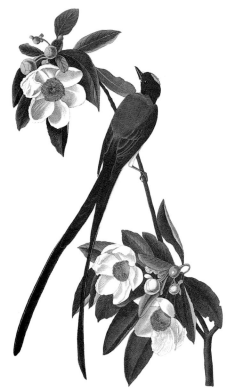

266 *Fork-tailed Flycatcher*
Passeriformes Tyrannidae *Tyrannus savana*

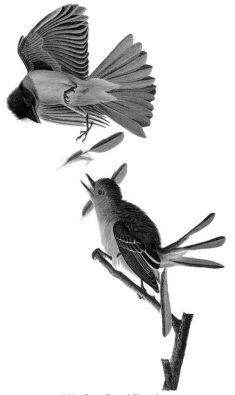

267 *Great Crested Flycatcher*
Passeriformes Tyrannidae *Myiarchus crinitus*

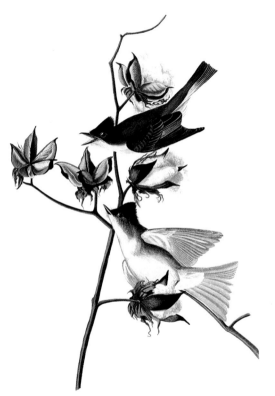

268 *Eastern Phoebe [Pewit Flycatcher]*
Passeriformes Tyrannidae *Sayornis phoebe*

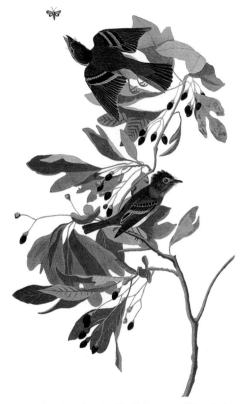

269 *Acadian Flycatcher [Small Green-crested Flycatcher]*
Passeriformes Tyrannidae *Empidonax virescens*

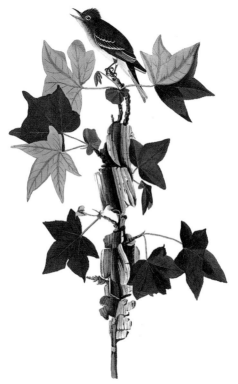

270 *Willow Flycatcher [Traill's Flycatcher]*
Passeriformes Tyrannidae *Empidonax traillii*

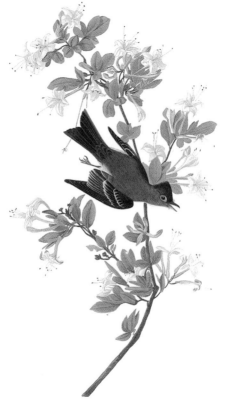

271 *Eastern Wood-Pewee [Wood Pewee]*
Passeriformes Tyrannidae *Contopus virens*

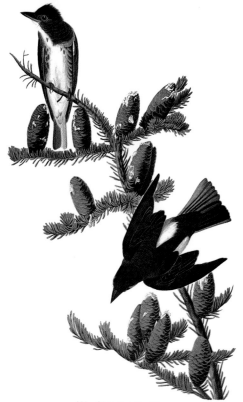

272 *Olive-sided Flycatcher*
Passeriformes Tyrannidae *Contopus borealis*

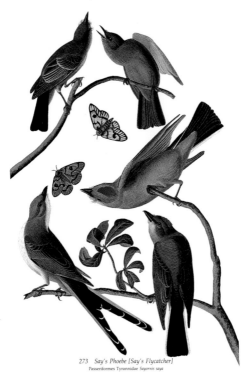

273 Say's Phoebe [Say's Flycatcher]
Passeriformes Tyrannidae *Sayornis saya*

Western Kingbird [Arkansaw Flycatcher]
Passeriformes Tyrannidae *Tyrannus verticalis*

Scissor-tailed Flycatcher [Swallow-tailed Flycatcher]
Passeriformes Tyrannidae *Tyrannus forficatus*

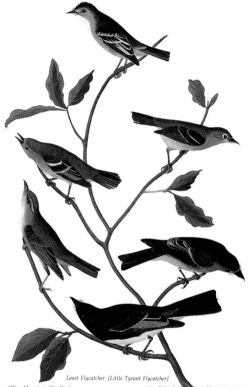

Least Flycatcher [Little Tyrant Flycatcher]

"Blue Mountain Warbler"

"Small-headed Warbler" [Small Headed Flycatcher]

Yellow-green Vireo [Bartram's Vireo]

Alder Flycatcher [Short-legged Pewee]

Black Phoebe [Rocky Mountain Flycatcher]

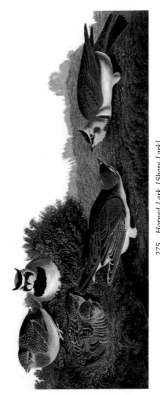

275 *Horned Lark* [*Shore Lark*]
Passeriformes Alaudidae *Eremophila alpestris*

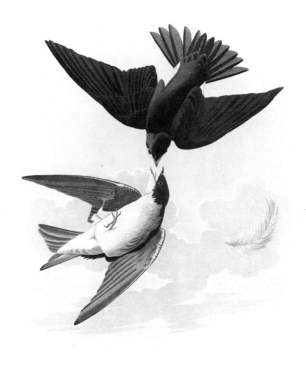

276 *Tree Swallow [White-bellied Swallow or Green-blue Swallow]*
Passeriformes Hirundinidae *Tachycineta bicolor*

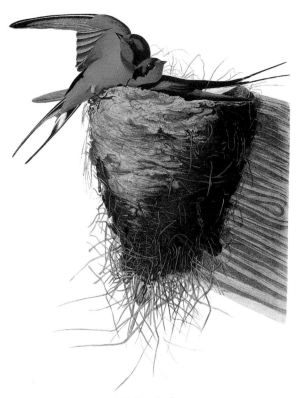

277 *Barn Swallow*
Passeriformes Hirundinidae *Hirundo rustica*

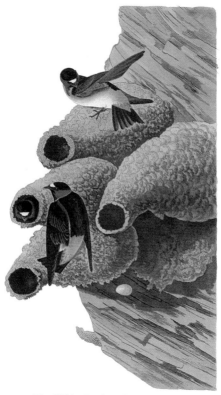

278 *Cliff Swallow [Republican Cliff Swallow]*
Passeriformes Hirundinidae *Hirundo pyrrhonota*

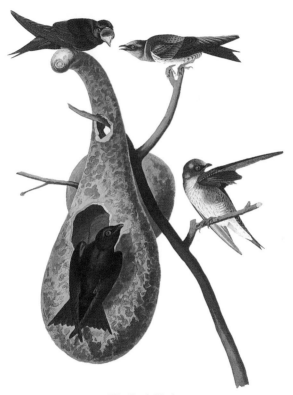

279 *Purple Martin*
Passeriformes Hirundinidae *Progne subis*

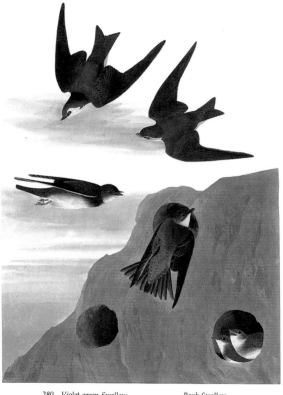

280 *Violet-green Swallow*
Passeriformes Hirundinidae *Tachycineta thalassina*

Bank Swallow
Passeriformes Hirundinidae *Riparia riparia*

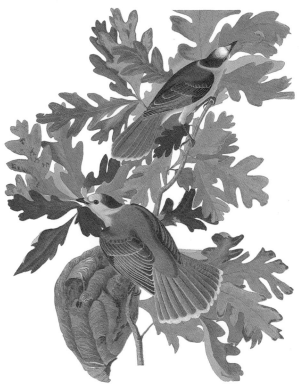

281 Gray Jay [Canada Jay]
Passeriformes Corvidae *Perisoreus canadensis*

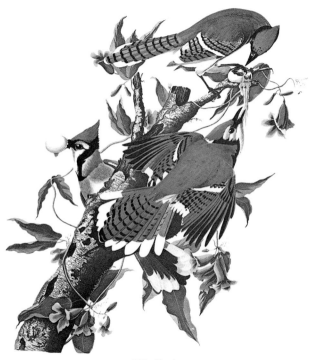

282 Blue Jay
Passeriformes Corvidae *Cyanocitta cristata*

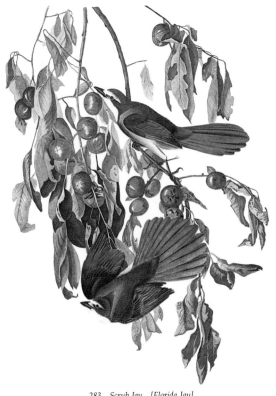

283 *Scrub Jay* [*Florida Jay*]

Passeriformes Corvidae *Aphelocoma coerulescens*

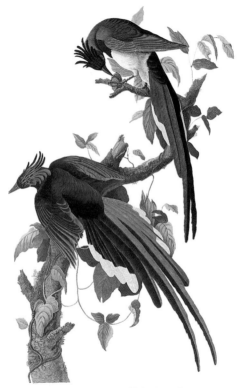

284 *Magpie Jay* [Columbia Jay]
Passeriformes Corvidae *Calocitta formosa*

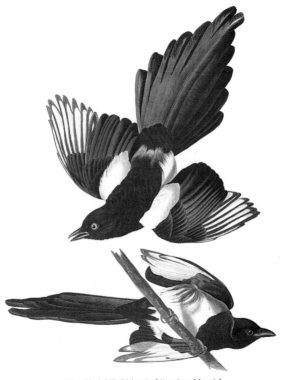

285 *Black-billed Magpie [American Magpie]*
Passeriformes Corvidae *Pica pica*

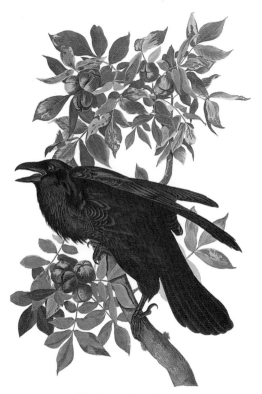

286 Common Raven [Raven]
Passeriformes Corvidae *Corvus corax*

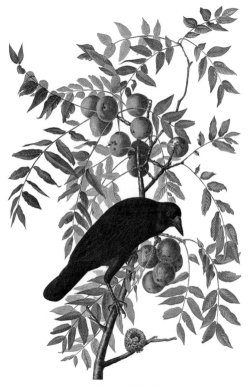

287 *American Crow*
Passeriformes Corvidae *Corvus brachyrhynchos*

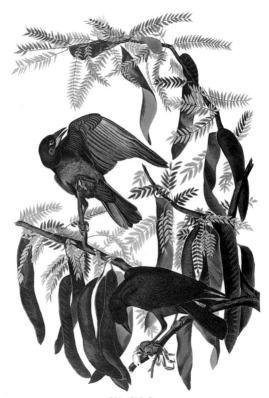

288 Fish Crow
Passeriformes Corvidae *Corvus ossifragus*

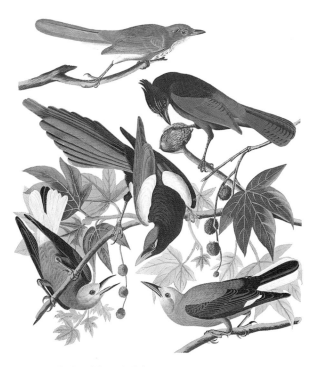

289 *Scrub Jay* [*Ultramarine Jay*]
Passeriformes Corvidae *Aphelocoma coerulescens*
Steller's Jay
Passeriformes Corvidae *Cyanocitta stelleri*

Yellow-billed Magpie
Passeriformes Corvidae *Pica nuttalli*
Clark's Nutcracker [*Clark's Crow*]
Passeriformes Corvidae *Nucifraga columbiana*

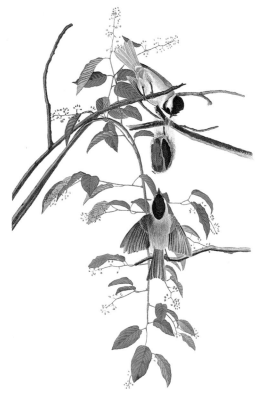

290 *Carolina Chickadee [Black-capped Titmouse]*

Passeriformes Paridae *Parus carolinensis*

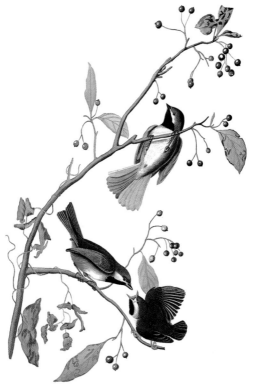

291 *Boreal Chickadee [Canadian Titmouse]*
Passeriformes Paridae *Parus hudsonicus*

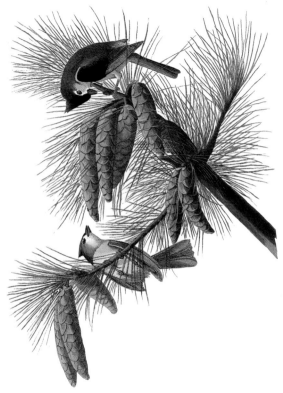

292 *Tufted Titmouse* [*Crested Titmouse*]
Passeriformes Paridae *Parus bicolor*

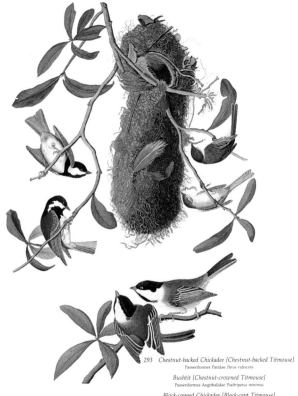

293 *Chestnut-backed Chickadee [Chestnut-backed Titmouse]*
Passeriformes Paridae *Parus rufescens*

Bushtit [Chestnut-crowned Titmouse]
Passeriformes Aegithalidae *Psaltriparus minimus*

Black-capped Chickadee [Black-capt Titmouse]
Passeriformes Paridae *Parus atricapillus*

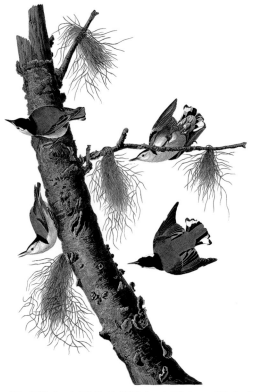

294 *White-breasted Nuthatch [White-breasted Black-capped Nuthatch]*
Passeriformes Sittidae *Sitta carolinensis*

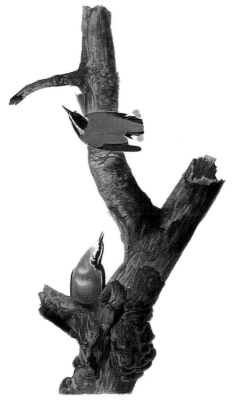

295 *Red-breasted Nuthatch*
Passeriformes Sittidae *Sitta canadensis*

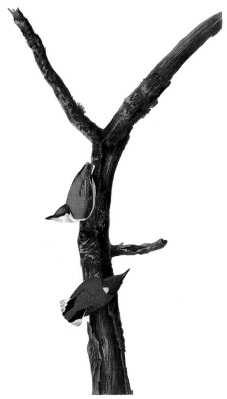

296 Brown-headed Nuthatch
Passeriformes Sittidae *Sitta pusilla*

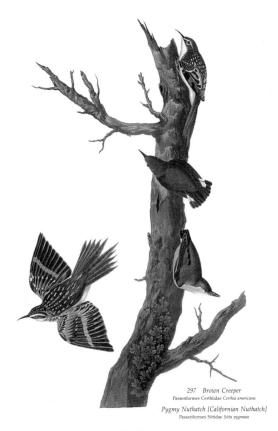

297 Brown Creeper
Passeriformes Certhiidae *Certhia americana*

Pygmy Nuthatch [Californian Nuthatch]
Passeriformes Sittidae *Sitta pygmaea*

IX

SONGSTERS AND MIMICS

Dippers, Wrens, Mockingbirds, Thrashers, Thrushes,
Gnatcatchers, Kinglets, Pipits, Waxwings, and Shrikes

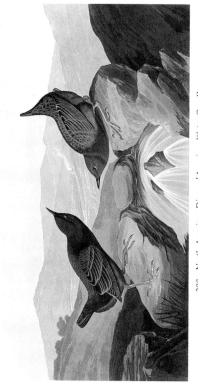

298 *North American Dipper [American Water Ouzel]*
Passeriformes Cinclidae *Cinclus mexicanus*

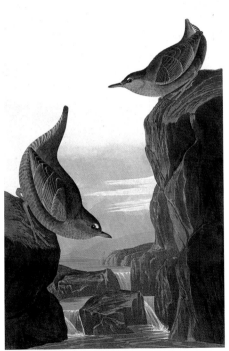

299 *American Dipper [Columbian and Arctic Water Ouzels]*
Passeriformes Cinclidae *Cinclus mexicanus*

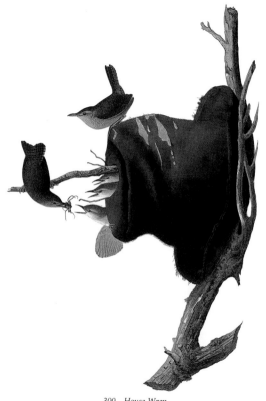

300 House Wren
Passeriformes Troglodytidae *Troglodytes aedon*

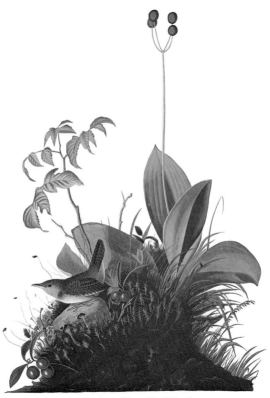

301 House Wren [Wood Wren]
Passeriformes Troglodytidae *Troglodytes aedon*

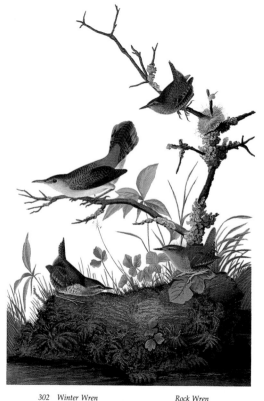

302 Winter Wren

Rock Wren

Passeriformes Troglodytidae *Troglodytes troglodytes*

Passeriformes Troglodytidae *Salpinctes obsoletus*

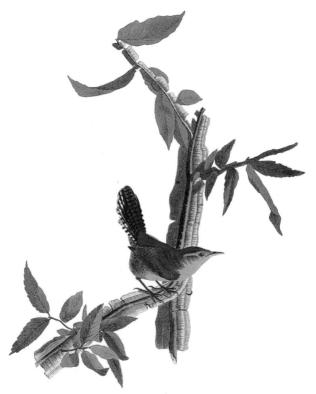

303 *Bewick's Wren [Bewick's Long-tailed Wren]*
Passeriformes Troglodytidae *Thryomanes bewickii*

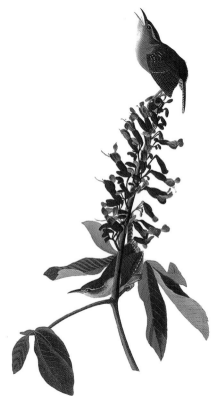

304 *Carolina Wren [Great Carolina Wren]*
Passeriformes Troglodytidae *Thryothorus ludovicianus*

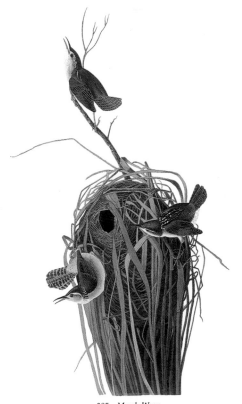

305 Marsh Wren
Passeriformes Troglodytidae *Cistothorus palustris*

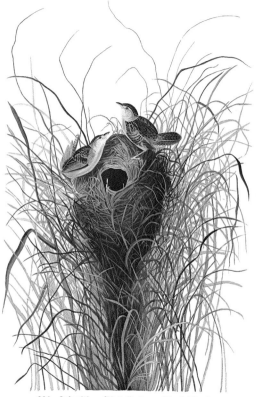

306 Sedge Wren [Nuttall's Lesser Marsh Wren]
Passeriformes Troglodytidae *Cistothorus platensis*

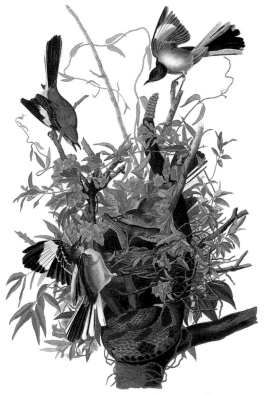

307 *Northern Mockingbird [Mocking Bird]*
Passeriformes Mimidae *Mimus polyglottos*

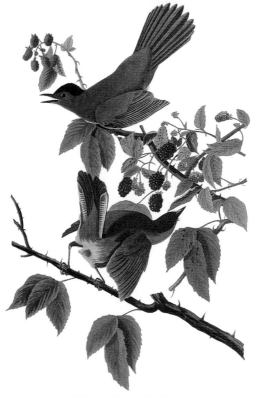

308 Gray Catbird [Cat Bird]
Passeriformes Mimidae *Dumetella carolinensis*

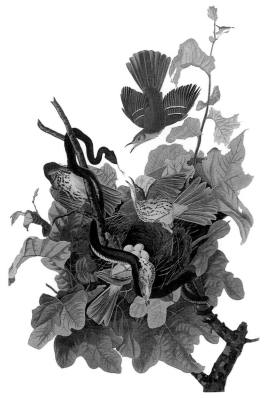

309 *Brown Thrasher [Ferruginous Thrush]*
Passeriformes Mimidae *Toxostoma rufum*

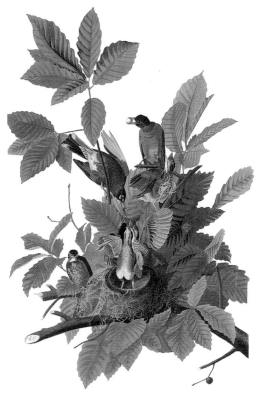

310 American Robin
Passeriformes Muscicapidae *Turdus migratorius*

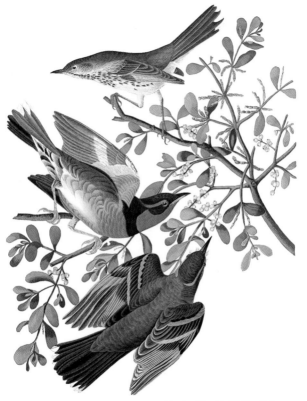

311 *Varied Thrush* *Sage Thrasher* [*Mountain Mocking Bird*]
Passeriformes Muscicapidae *Ixoreus naevius* Passeriformes Mimidae *Oreoscoptes montanus*

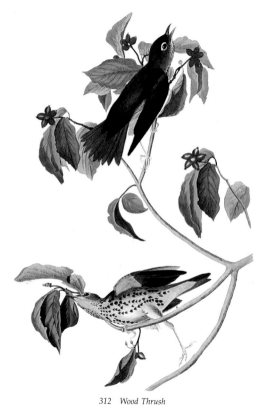

312 Wood Thrush
Passeriformes Muscicapidae *Hylocichla mustelina*

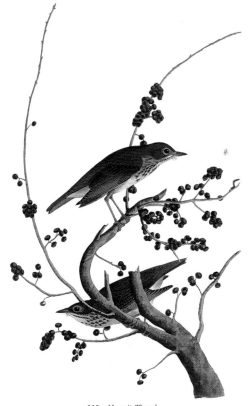

313 Hermit Thrush
Passeriformes Muscicapidae *Catharus guttatus*

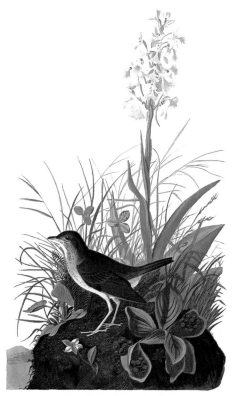

314 *Veery [Tawny Thrush]*
Passeriformes Muscicapidae *Catharus fuscescens*

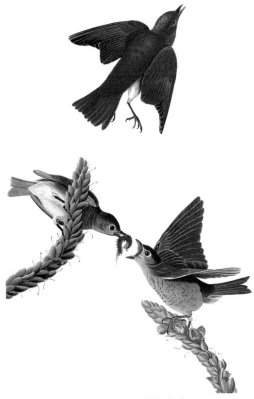

315 Eastern Bluebird [Blue-bird]
Passeriformes Muscicapidae *Sialia sialis*

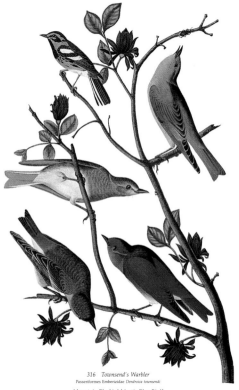

316 *Townsend's Warbler*
Passeriformes Emberizidae *Dendroica townsendi*

Mountain Bluebird [Arctic Blue Bird]
Passeriformes Muscicapidae *Sialia currucoides*

Western Bluebird [Western Blue Bird]
Passeriformes Muscicapidae *Sialia mexicana*

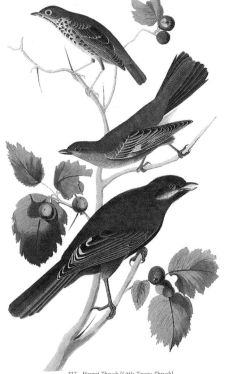

317 *Hermit Thrush [Little Tawny Thrush]*
Passeriformes Muscicapidae *Catharus guttatus*

Townsend's Solitaire [Townsend's Ptilogonys]
Passeriformes Muscicapidae *Myadestes townsendi*

Gray Jay [Canada Jay]
Passeriformes Corvidae *Perisoreus canadensis*

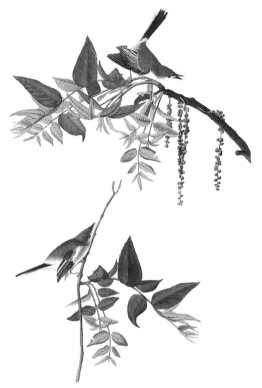

318 *Blue-gray Gnatcatcher [Blue-grey Flycatcher]*

Passeriformes Muscicapidae Polioptila caerulea

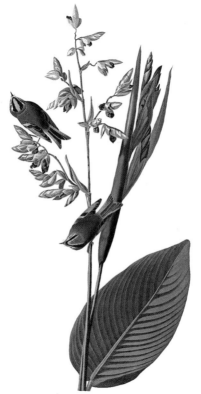

319 Golden-crowned Kinglet [Golden-crested Wren]
Passeriformes Muscicapidae *Regulus satrapa*

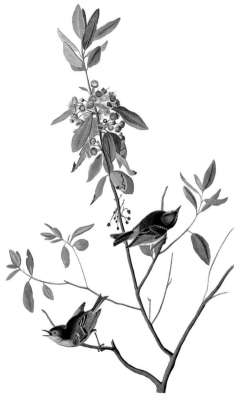

320 *Ruby-crowned Kinglet [Ruby-crowned Wren]*
Passeriformes Muscicapidae *Regulus calendula*

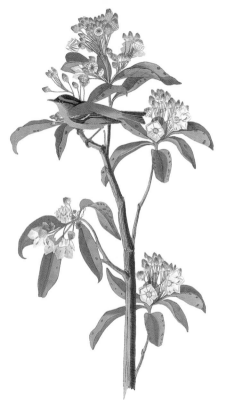

321 "Cuvier's Kinglet" [Cuvier's Wren]
Passeriformes Muscicapidae "Regulus cuvieri"

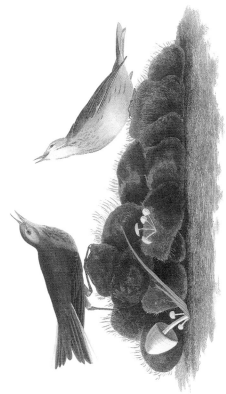

322 *American Pipit [Brown Titlark]*
Passeriformes Motacillidae *Anthus rubescens*

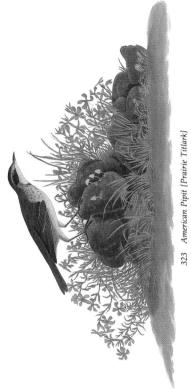

323 *American Pipit [Prairie Titlark]*
Passeriformes Motacillidae *Anthus rubescens*

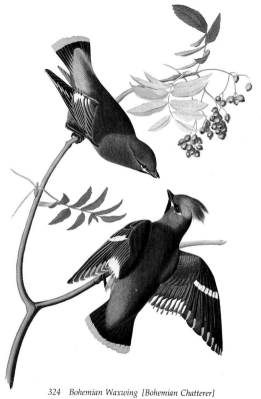

324 *Bohemian Waxwing* [Bohemian Chatterer]
Passeriformes Bombycillidae *Bombycilla garrulus*

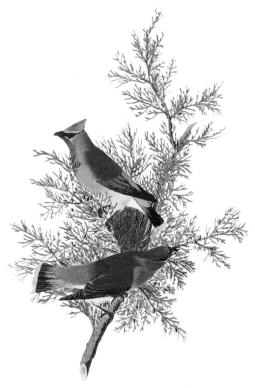

325 Cedar Waxwing [Cedar Bird]
Passeriformes Bombycillidae *Bombycilla cedrorum*

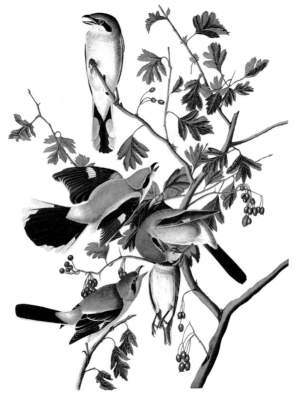

326 *Northern Shrike [Great American Shrike or Butcher Bird]*
Passeriformes Laniidae *Lanius excubitor*

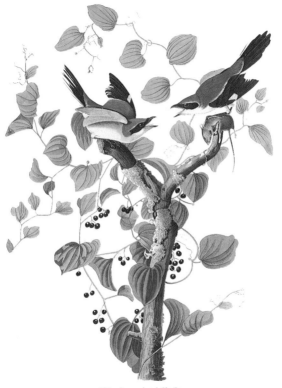

327 Loggerhead Shrike
Passeriformes Laniidae *Lanius ludovicianus*

WOODLAND SPRITES

Vireos and Warblers

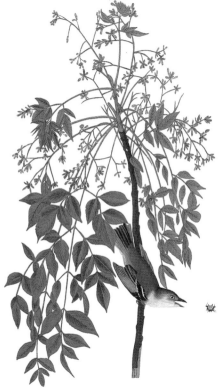

328 *White-eyed Vireo [White-eyed Flycatcher or Vireo]*
Passeriformes Vireonidae *Vireo griseus*

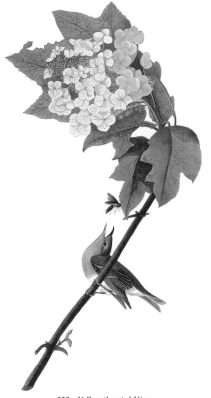

329 Yellow-throated Vireo
Passeriformes Vireonidae *Vireo flavifrons*

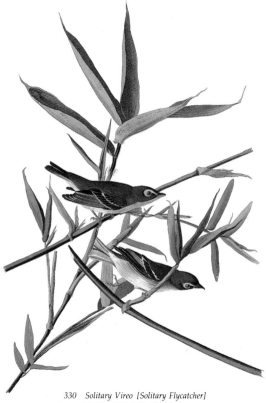

330 *Solitary Vireo [Solitary Flycatcher]*
Passeriformes Vireonidae *Vireo solitarius*

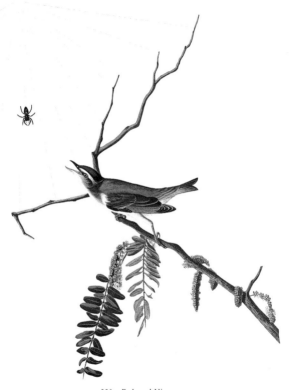

331 Red-eyed Vireo
Passeriformes Vireonidae *Vireo olivaceus*

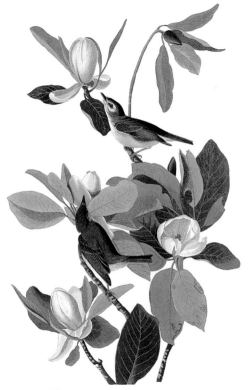

332 *Warbling Vireo [Warbling Flycatcher]*
Passeriformes Vireonidae *Vireo gilvus*

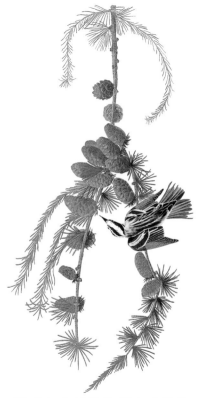

333 *Black-and-white Warbler [Black-and-white Creeper]*
Passeriformes Emberizidae *Mniotilta varia*

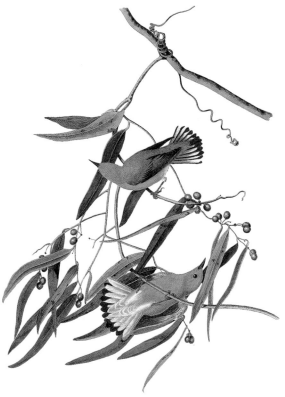

334 *Prothonotary Warbler*
Passeriformes Emberizidae *Protonotaria citrea*

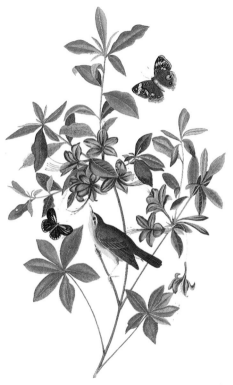

335 *Swainson's Warbler [Brown-headed Worm-eating Warbler]*
Passeriformes Emberizidae *Limnothlypis swainsonii*

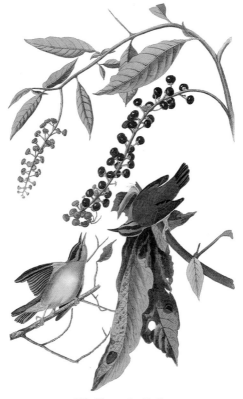

336 Worm-eating Warbler
Passeriformes Emberizidae *Helmitheros vermivorus*

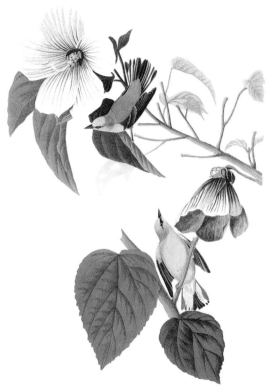

337 *Blue-winged Warbler [Blue-winged Yellow Warbler]*
Passeriformes Emberizidae *Vermivora pinus*

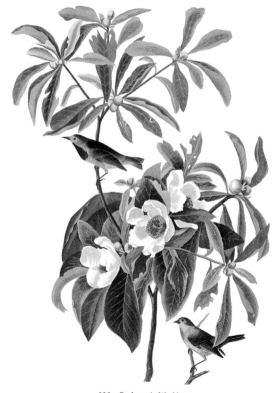

338 *Bachman's Warbler*

Passeriformes Emberizidae *Vermivora bachmanii*

339 Tennessee Warbler
Passeriformes Emberizidae *Vermivora peregrina*

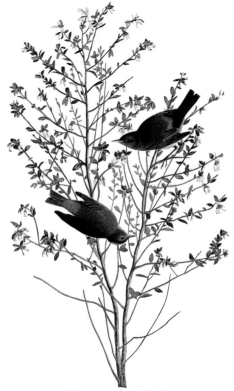

340 *Orange-crowned Warbler*
Passeriformes Emberizidae *Vermivora celata*

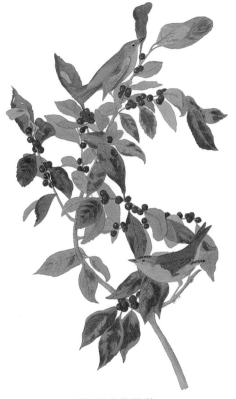

341 *Nashville Warbler*
Passeriformes Emberizidae *Vermivora ruficapilla*

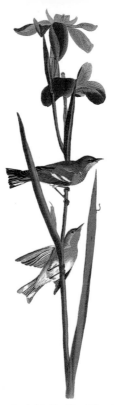

342 *Northern Parula Warbler [Blue Yellow-back Warbler]*
Passeriformes Emberizidae *Parula americana*

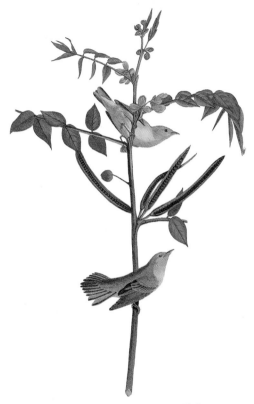

343 *Yellow Warbler [Children's Warbler]*
Passeriformes Emberizidae *Dendroica petechia*

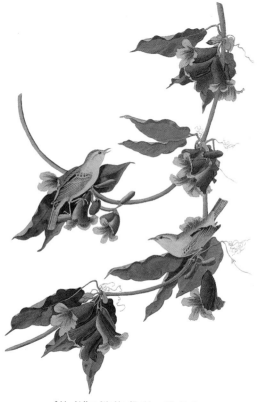

344 *Yellow Warbler [Rathbone Warbler]*
Passeriformes Emberizidae *Dendroica petechia*

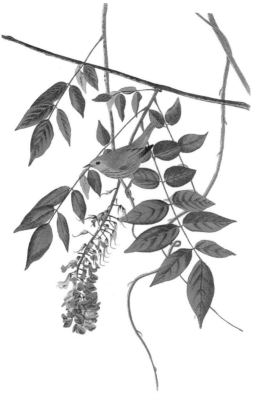

345 *Yellow Warbler [Blue-eyed Yellow Warbler]*
Passeriformes Emberizidae *Dendroica petechia*

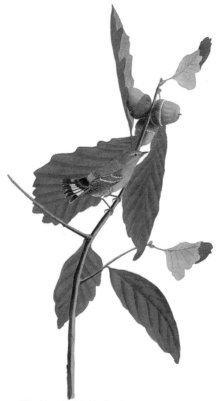

346 *Magnolia Warbler [Black and Yellow Warbler]*
Passeriformes Emberizidae *Dendroica magnolia*

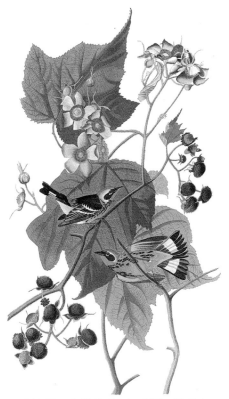

347 *Magnolia Warbler [Black and Yellow Warbler]*
Passeriformes Emberizidae *Dendroica magnolia*

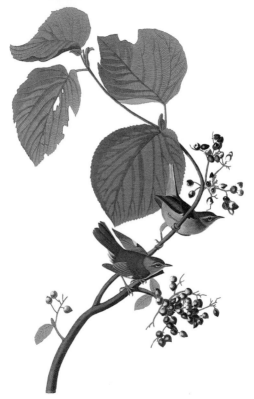

348 *Black-throated Blue Warbler* [*Pine Swamp Warbler*]
Passeriformes Emberizidae *Dendroica caerulescens*

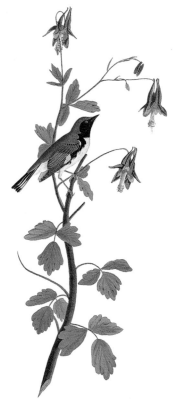

349 Black-throated Blue Warbler
Passeriformes Emberizidae *Dendroica caerulescens*

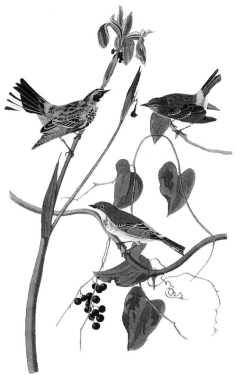

350　*Yellow-rumped Warbler [Yellow-crown Warbler]*
Passeriformes Emberizidae *Dendroica coronata*

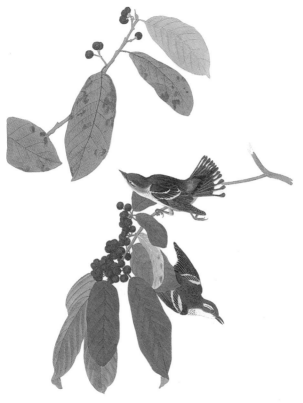

351 *Cerulean Warbler*
Passeriformes Emberizidae *Dendroica cerulea*

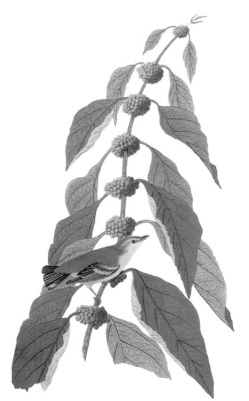

352 *Cerulean Warbler [Blue-green Warbler]*
Passeriformes Emberizidae *Dendroica cerulea*

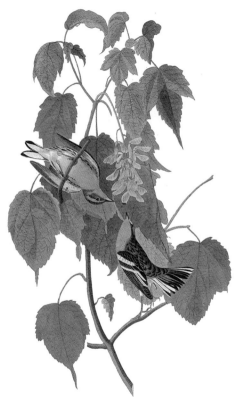

353 *Blackburnian Warbler [Hemlock Warbler]*
Passeriformes Emberizidae *Dendroica fusca*

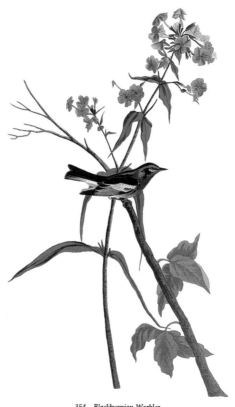

354 Blackburnian Warbler

Passeriformes Parulidae *Dendroica fusca*

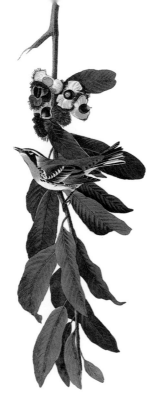

355 Yellow-throated Warbler [Yellow-throat Warbler]

Passeriformes Emberizidae *Dendroica dominica*

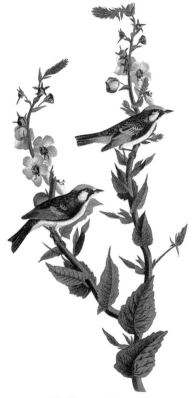

356 Chestnut-sided Warbler
Passeriformes Emberizidae *Dendroica pensylvanica*

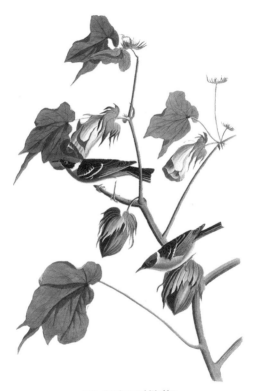

357 *Bay-breasted Warbler*
Passeriformes Emberizidae *Dendroica castanea*

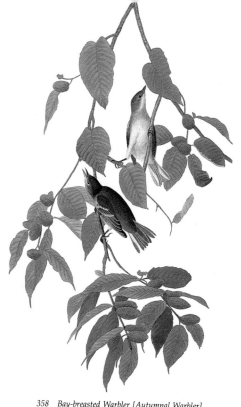

358 *Bay-breasted Warbler* [*Autumnal Warbler*]
Passeriformes Emberizidae *Dendroica castanea*

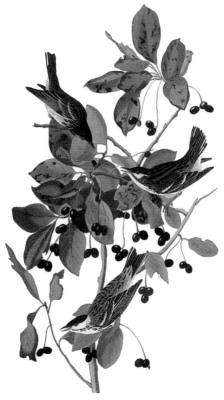

359 *Blackpoll Warbler [Black-poll Warbler]*
Passeriformes Emberizidae *Dendroica striata*

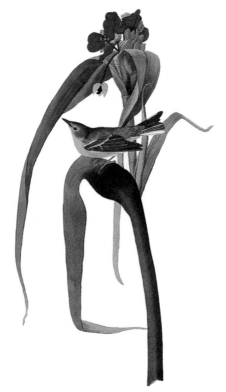

360 *Pine Warbler [Vigors' Warbler]*
Passeriformes Emberizidae *Dendroica pinus*

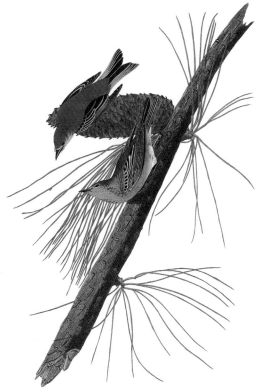

361 *Pine Warbler* [*Pine Creeping Warbler*]
Passeriformes Emberizidae *Dendroica pinus*

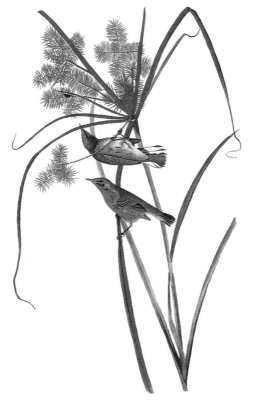

362 *Prairie Warbler*
Passeriformes Emberizidae *Dendroica discolor*

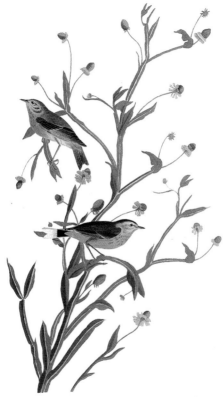

363 *Palm Warbler* [*Yellow Red-poll Warbler*]
Passeriformes Emberizidae *Dendroica palmarum*

364 Palm Warbler

Passeriformes Emberizidae *Dendroica palmarum*

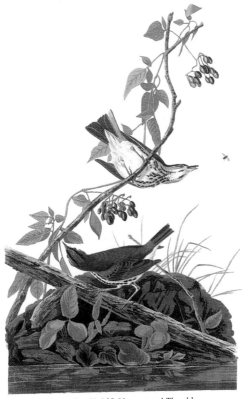

365 Ovenbird [Golden-crowned Thrush]
Passeriformes Emberizidae *Seiurus aurocapillus*

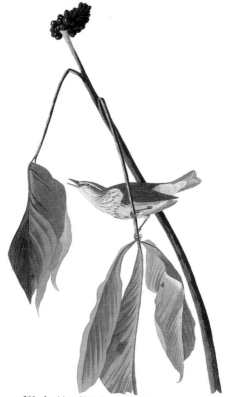

366 *Louisiana Waterthrush* [Louisiana Water Thrush]
Passeriformes Emberizidae *Seiurus motacilla*

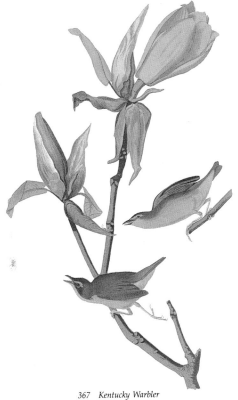

367 *Kentucky Warbler*
Passeriformes Emberizidae *Oporornis formosus*

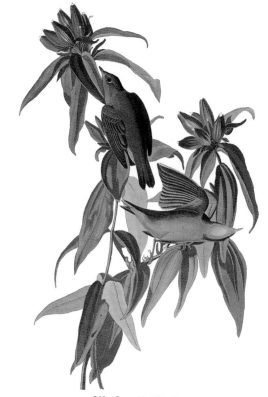

368 Connecticut Warbler
Passeriformes Emberizidae *Oporornis agilis*

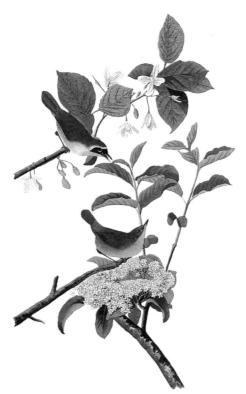

369 *Common Yellowthroat [Maryland Yellow-throat]*
Passeriformes Emberizidae *Geothlypis trichas*

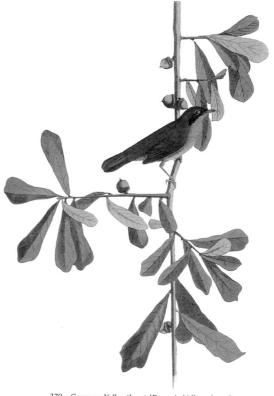

370 *Common Yellowthroat [Roscoe's Yellow-throat]*
Passeriformes Emberizidae *Geothlypis trichas*

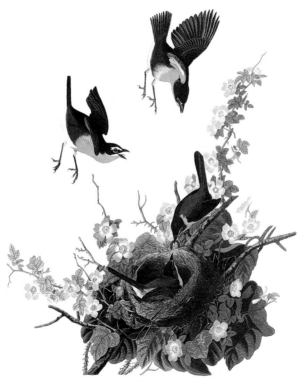

371 Yellow-breasted Chat
Passeriformes Emberizidae *Icteria virens*

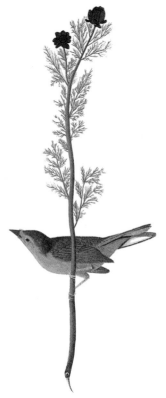

372 *Hooded Warbler [Selby's Flycatcher]*
Passeriformes Emberizidae *Wilsonia citrina*

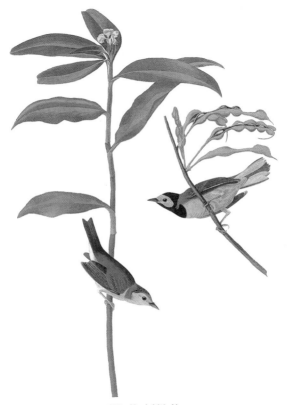

373　*Hooded Warbler*
Passeriformes Emberizidae *Wilsonia citrina*

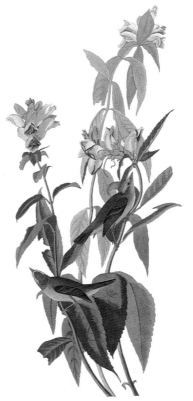

374 *Wilson's Warbler [Green Black-capt Flycatcher]*
Passeriformes Emberizidae *Wilsonia pusilla*

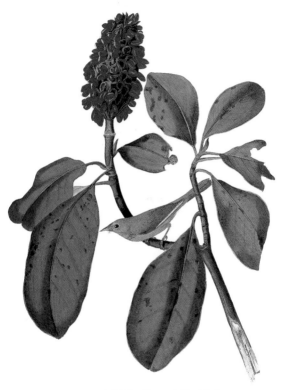

375 *Canada Warbler [Bonaparte Flycatcher]*
Passeriformes Emberizidae *Wilsonia canadensis*

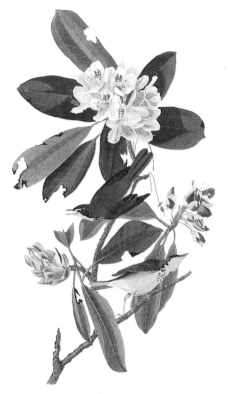

376 *Canada Warbler*
Passeriformes Emberizidae *Wilsonia canadensis*

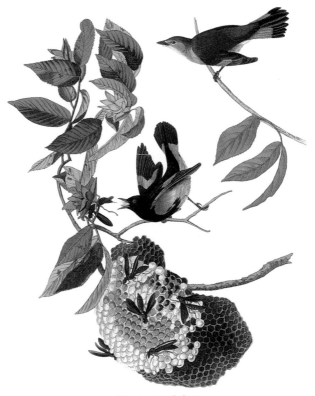

377 *American Redstart*
Passeriformes Emberizidae *Setophaga ruticilla*

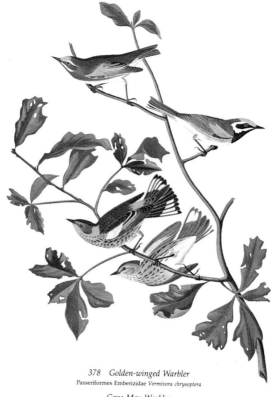

378 Golden-winged Warbler
Passeriformes Emberizidae *Vermivora chrysoptera*

Cape May Warbler
Passeriformes Emberizidae *Dendroica tigrina*

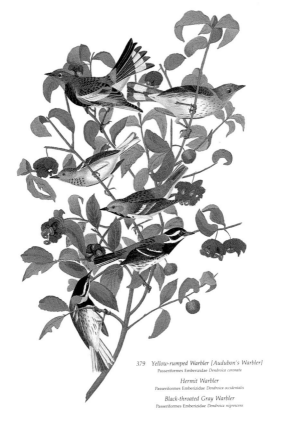

379 *Yellow-rumped Warbler [Audubon's Warbler]*
Passeriformes Emberizidae *Dendroica coronata*

Hermit Warbler
Passeriformes Emberizidae *Dendroica occidentalis*

Black-throated Gray Warbler
Passeriformes Emberizidae *Dendroica nigrescens*

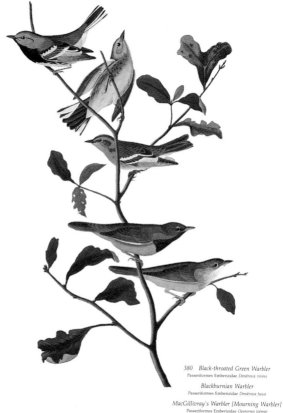

380 *Black-throated Green Warbler*
Passeriformes Emberizidae *Dendroica virens*

Blackburnian Warbler
Passeriformes Emberizidae *Dendroica fusca*

MacGillivray's Warbler [Mourning Warbler]
Passeriformes Emberizidae *Oporornis tolmiei*

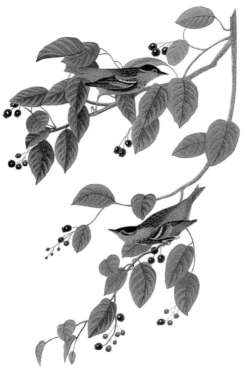

381 "Carbonated Warbler"
Passeriformes Emberizidae *"Dendroica carbonata"*

XI

FLOCKERS AND
SONGBIRDS

Meadowlarks, Blackbirds, Orioles,

Tanagers, and Finches

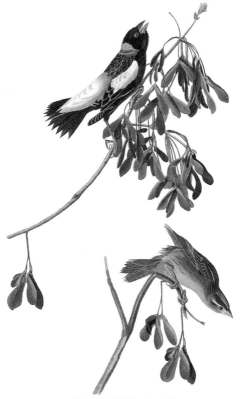

382 *Bobolink [Rice Bunting]*
Passeriformes Emberizidae *Dolichonyx oryzivorus*

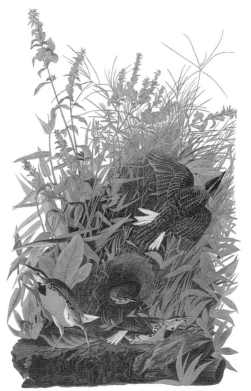

383 *Eastern Meadowlark [Meadow Lark]*
Passeriformes Emberizidae *Sturnella magna*

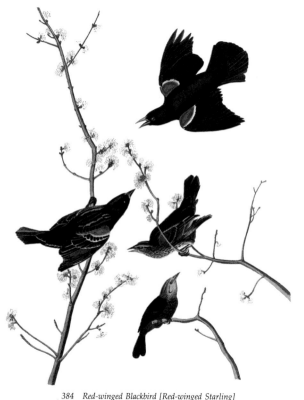

384 *Red-winged Blackbird [Red-winged Starling]*
Passeriformes Emberizidae *Agelaius phoeniceus*

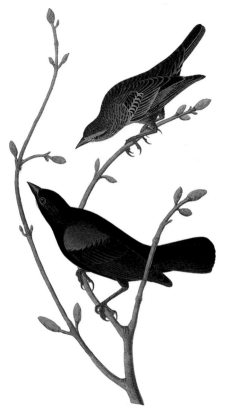

385 Red-winged Blackbird [Prairie Starling]
Passeriformes Emberizidae *Agelaius phoeniceus*

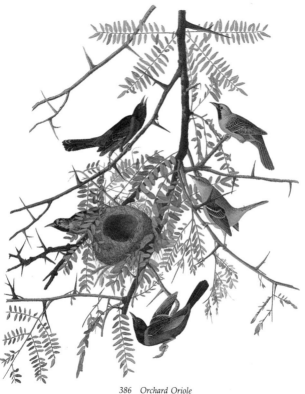

386 *Orchard Oriole*
Passeriformes Emberizidae *Icterus spurius*

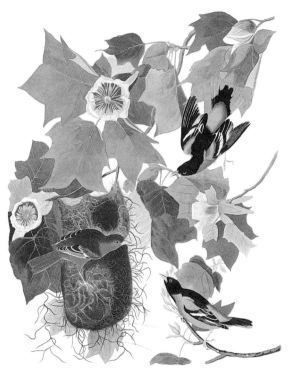

387 *Northern Oriole [Baltimore Oriole]*
Passeriformes Emberizidae *Icterus galbula*

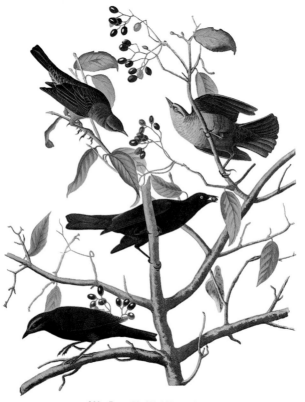

388 *Rusty Blackbird [Rusty Grakle]*
Passeriformes Emberizidae *Euphagus carolinus*

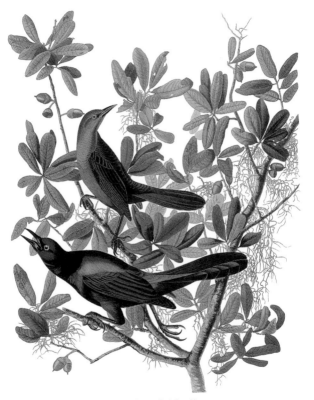

389 Boat-tailed Grackle
Passeriformes Emberizidae *Quiscalus major*

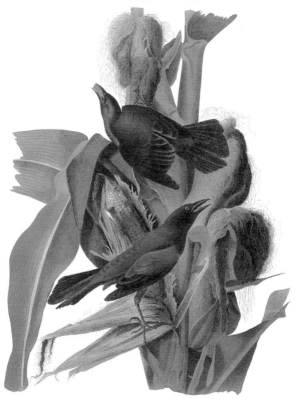

390 *Common Grackle [Purple Grackle]*
Passeriformes Emberizidae *Quiscalus quiscula*

391 *Brown-headed Cowbird [Cow Bunting]*
Passeriformes Emberizidae *Molothrus ater*

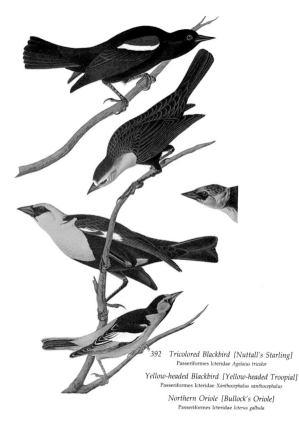

392 *Tricolored Blackbird [Nuttall's Starling]*
Passeriformes Icteridae *Agelaius tricolor*

Yellow-headed Blackbird [Yellow-headed Troopial]
Passeriformes Icteridae *Xanthocephalus xanthocephalus*

Northern Oriole [Bullock's Oriole]
Passeriformes Icteridae *Icterus galbula*

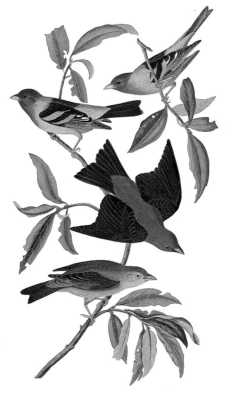

393 *Western Tanager [Louisiana Tanager]* *Scarlet Tanager [Black-winged Red-bird]*
Passeriformes Emberizidae *Piranga ludoviciana* Passeriformes Emberizidae *Piranga olivacea*

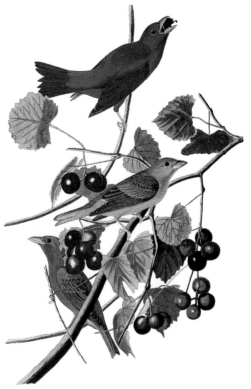

394 *Summer Tanager [Summer Red Bird]*
Passeriformes Emberizidae *Piranga rubra*

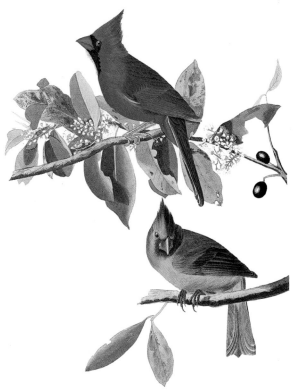

395 *Northern Cardinal [Cardinal Grosbeak]*
Passeriformes Emberizidae *Cardinalis cardinalis*

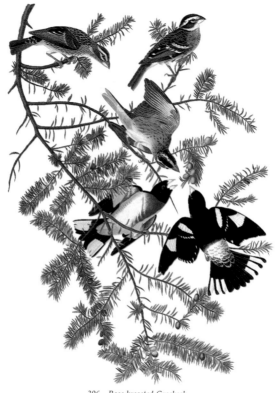

396 Rose-breasted Grosbeak
Passeriformes Emberizidae *Pheucticus ludovicianus*

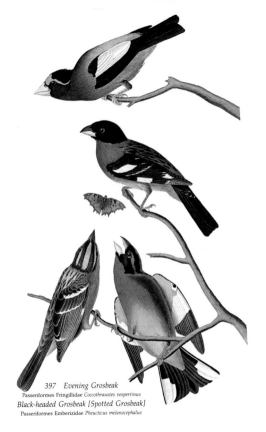

397 *Evening Grosbeak*
Passeriformes Fringillidae *Coccothraustes vespertinus*
Black-headed Grosbeak [Spotted Grosbeak]
Passeriformes Emberizidae *Pheucticus melanocephalus*

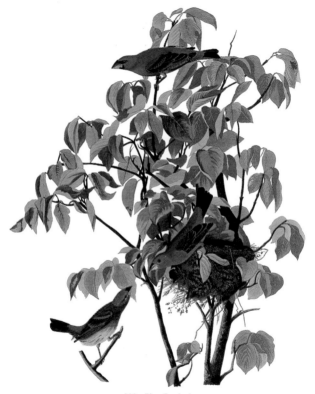

398 Blue Grosbeak
Passeriformes Emberizidae *Guiraca caerulea*

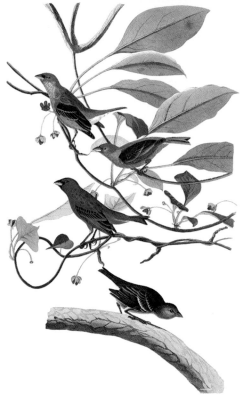

399 *Indigo Bunting [Indigo Bird]*
Passeriformes Emberizidae *Passerina cyanea*

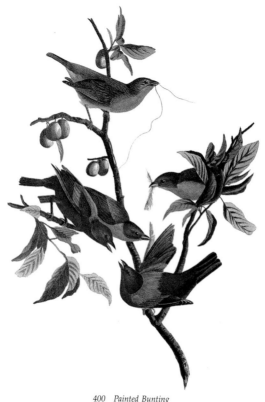

400 *Painted Bunting*
Passeriformes Emberizidaé *Passerina ciris*

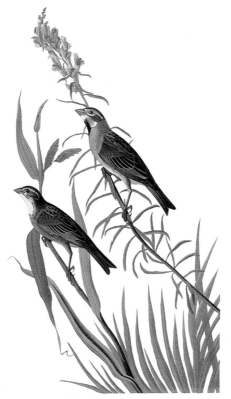

401 *Dickcissel [Black-throated Bunting]*
Passeriformes Fringillidae *Spiza americana*

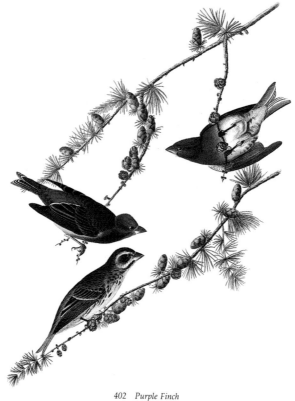

402 *Purple Finch*

Passeriformes Fringillidae *Carpodacus purpureus*

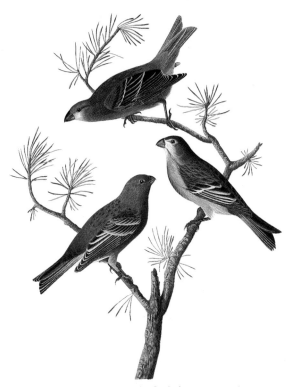

403 Pine Grosbeak
Passeriformes Fringillidae *Pinicola enucleator*

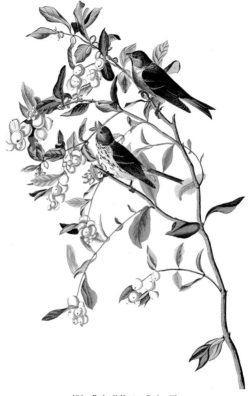

404 *Redpoll [Lesser Red-poll]*
Passeriformes Fringillidae *Carduelis flammea*

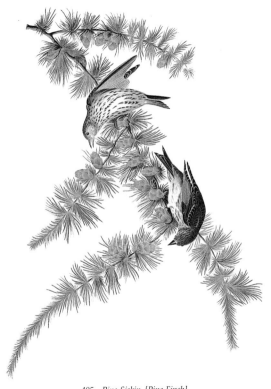

405 *Pine Siskin [Pine Finch]*
Passeriformes Fringillidae *Carduelis pinus*

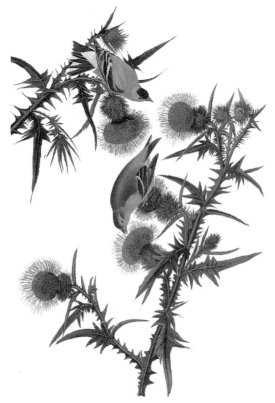

406 *American Goldfinch [Yellow Bird]*
Passeriformes Fringillidae *Carduelis tristis*

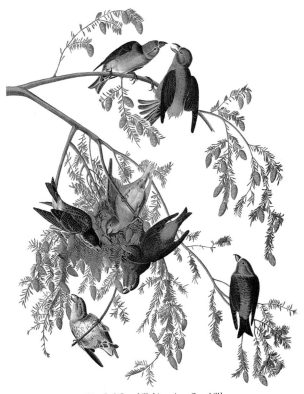

407 *Red Crossbill [American Crossbill]*
Passeriformes Fringillidae *Loxia curvirostra*

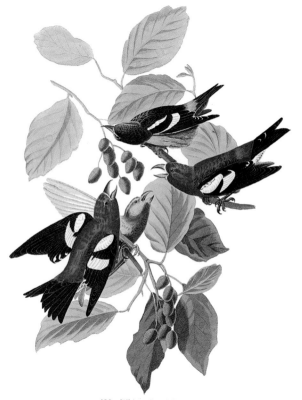

408 *White-winged Crossbill*
Passeriformes Fringillidae *Loxia leucoptera*

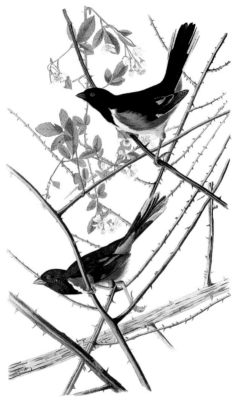

409 Rufous-sided Towhee [Towee Bunting]
Passeriformes Emberizidae *Pipilo erythrophthalmus*

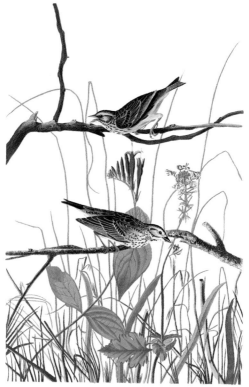

410 *Savannah Sparrow* [Savannah Finch]
Passeriformes Emberizidae *Passerculus sanwichensis*

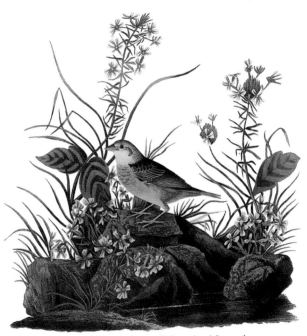

411 *Grasshopper Sparrow [Yellow-winged Sparrow]*
Passeriformes Emberizidae *Ammodramus savannarum*

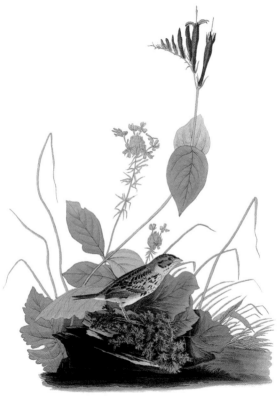

412 *Henslow's Sparrow [Henslow's Bunting]*
Passeriformes Emberizidae *Ammodramus henslowii*

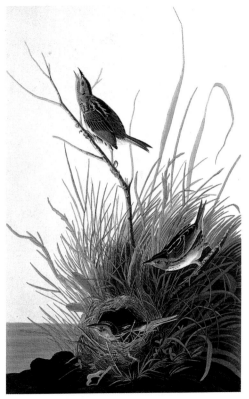

413 *Sharp-tailed Sparrow [Sharp-tailed Finch]*
Passeriformes Fringillidae *Ammospiza caudacuta*

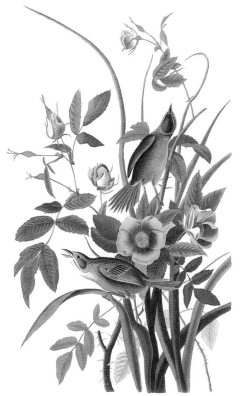

414 *Seaside Sparrow [Sea-side Finch]*
Passeriformes Emberizidae *Ammodramus maritimus*

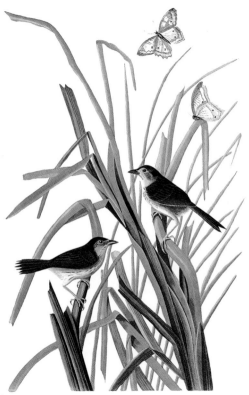

415 *Seaside Sparrow* [MacGillivray's Finch]
Passeriformes Emberizidae *Ammodramus maritimus*

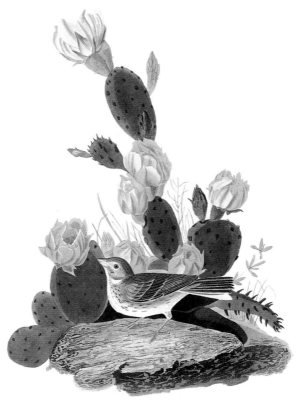

416 *Vesper Sparrow [Bay-winged Bunting]*
Passeriformes Emberizidae *Pooecetes gramineus*

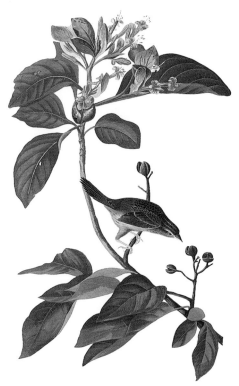

417 *Bachman's Sparrow [Bachman's Finch]*
Passeriformes Emberizidae *Aimophila aestivalis*

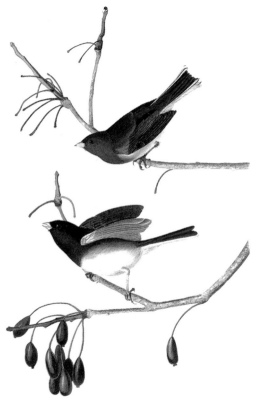

418 Dark-eyed Junco [Snow Bird]
Passeriformes Emberizidae *Junco hyemalis*

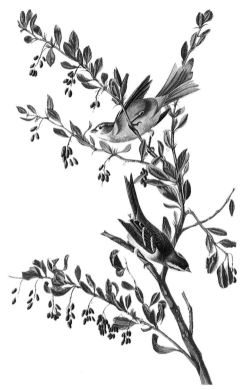

419 *American Tree Sparrow [Tree Sparrow]*
Passeriformes Emberizidae *Spizella arborea*

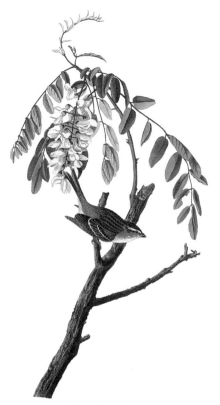

420 *Chipping Sparrow*
Passeriformes Fringillidae *Spizella passerina*

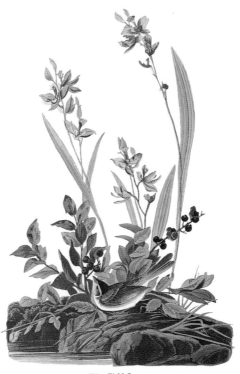

421 *Field Sparrow*
Passeriformes Emberizidae *Spizella pusilla*

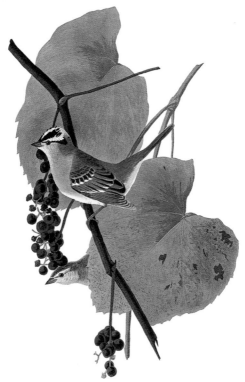

422 White-crowned Sparrow

Passeriformes Emberizidae *Zonotrichia leucophrys*

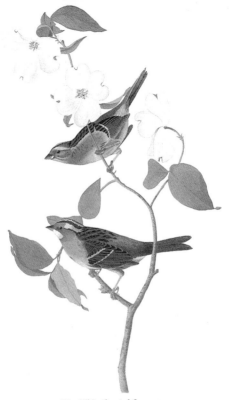

423 *White-throated Sparrow*

Passeriformes Emberizidae *Zonotrichia albicollis*

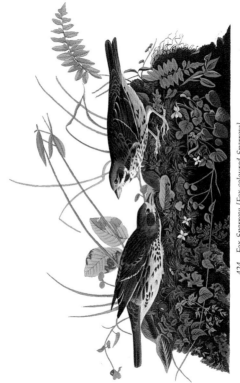

424 *Fox Sparrow [Fox-coloured Sparrow]*
Passeriformes Emberizidae *Passerella iliaca*

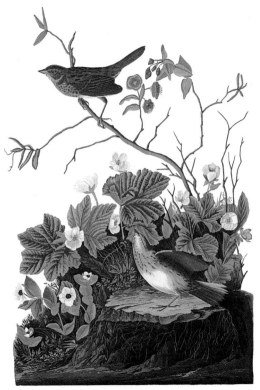

425 Lincoln's Sparrow [Lincoln Finch]
Passeriformes Emberizidae *Melospiza lincolnii*

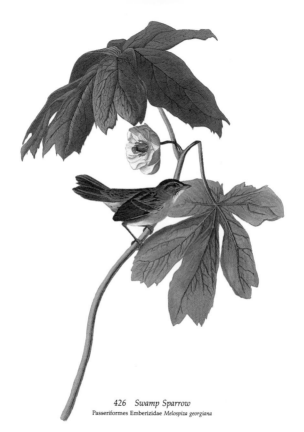

426 *Swamp Sparrow*
Passeriformes Emberizidae *Melospiza georgiana*

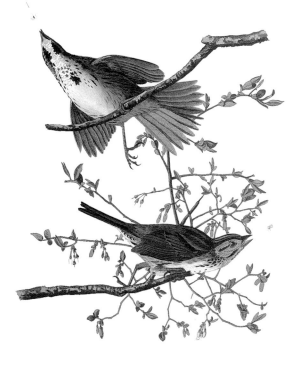

427 *Song Sparrow*
Passeriformes Emberizidae *Melospiza melodia*

428 *Lapland Longspur*
Passeriformes Emberizidae *Calcarius lapponicus*

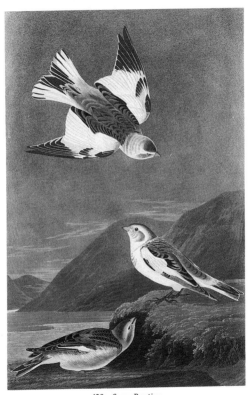

429 Snow Bunting
Passeriformes Emberizidae *Plectrophenax nivalis*

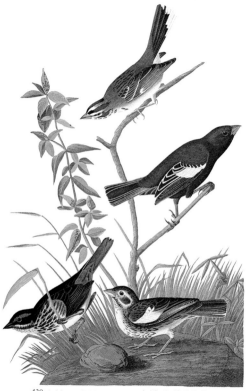

430 Lark Sparrow [Lark Finch]
Passeriformes Fringillidae *Chondestes grammacus*

Lark Bunting [Prairie Finch]
Passeriformes Fringillidae *Calamospiza melanocorys*

Song Sparrow [Brown Song Sparrow]
Passeriformes Fringillidae *Melospiza melodia*

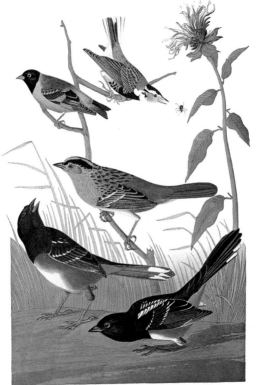

431 Chestnut-collared Longspur [Chestnut-coloured Finch]
Passeriformes Fringillidae *Calcarius ornatus*

Golden-crowned Sparrow [Black Crown Bunting]
Passeriformes Fringillidae *Zonotrichia atricapilla*

Black-headed Siskin
Passeriformes Fringillidae *Carduelis notatus*

Rufous-sided Towhee [Arctic Ground-finch]
Passeriformes Fringillidae *Pipilo erythrophthalmus*

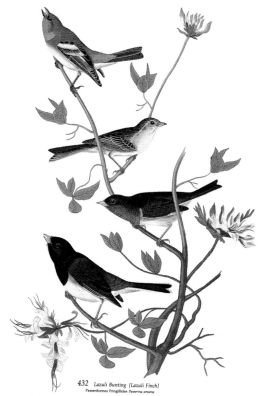

432 *Lazuli Bunting [Lazuli Finch]*
Passeriformes Fringillidae *Passerina amoena*

Northern Junco [Oregon Snow Finch]
Passeriformes Fringillidae *Junco hyemalis*

Clay-colored Sparrow [Clay-coloured Finch]
Passeriformes Fringillidae *Spizella pallida*

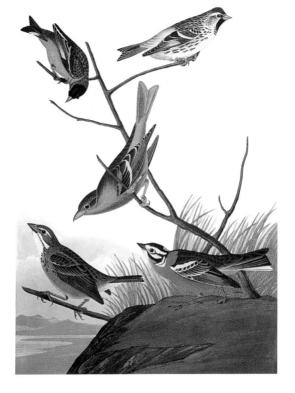

433 Lesser Goldfinch [Arkansaw Siskin]
Passeriformes Fringillidae *Carduelis psaltria*

"Townsend's Finch"
Passeriformes Fringillidae *Spiza townsendi*

Western Tanager [Louisiana Tanager]
Passeriformes Thraupidae *Piranga ludoviciana*

Hoary Redpoll [Mealy Red-poll]
Passeriformes Fringillidae *Carduelis hornemanni*

Smith's Longspur [Buff-breasted Finch]
Passeriformes Fringillidae *Calcarius pictus*

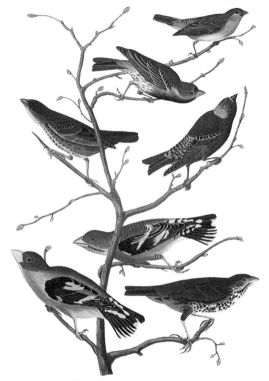

434 *Lazuli Bunting [Lazuli Finch]*
Passeriformes Emberizidae *Passerina amoena*

House Finch [Crimson-necked Bullfinch]
Passeriformes Fringillidae *Carpodacus mexicanus*

Rosy Finch [Grey-crowned Linnet]
Passeriformes Fringillidae *Leucosticte arctoa*

Brown-headed Cowbird [Cow-pen Bird]
Passeriformes Emberizidae *Molothrus ater*

Evening Grosbeak
Passeriformes Fringillidae *Coccothraustes vespertinus*

Fox Sparrow [Brown Longspur]
Passeriformes Emberizidae *Passerella iliaca*

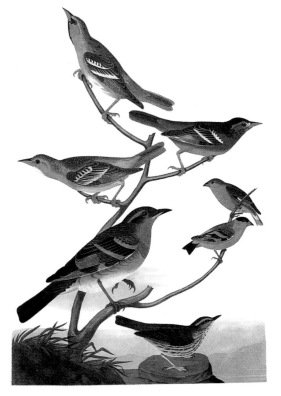

435 *Northern Oriole [Bullock's Oriole and Baltimore Oriole]*
Passeriformes Icteridae *Icterus galbula*

Varied Thrush
Passeriformes Turdidae *Ixoreus naevius*

Yellow-faced Siskin [Mexican Goldfinch]
Passeriformes Fringillidae *Spinus yarrelli*

Northern Waterthrush [Common Water Thrush]
Passeriformes Parulidae *Seiurus noveboracensis*